TANGLE ART PACK

A MEDITATIVE DRAWING BOOK AND SKETCHPAD

BECKAH KRAHULA

Quarry Books

100 Cummings Center, Suite 406L Beverly, MA 01915

quarrybooks.com • www.craftside.net

The content for this kit was compiled from the previously published title *One Zentangle a Day* [Quarry Books, 2012].

© 2015 by Quarry Books

First published in the United States of America in 2015 by Quarry Books, a member of Quarto Publishing Group USA Inc. 100 Cummings Center Suite 406-L Beverly. Massachusetts 01915-6101

Telephone: (978) 282-9590 Fax: (978) 283-2742 www.quarrybooks.com

Visit www.craftside.net for a behind-the-scenes peek at our crafty world!

All rights reserved. No part of this book may be reproduced in any form without written permission of the copyright owners. All images in this book have been reproduced with the knowledge and prior consent of the artists concerned, and no responsibility is accepted by the producer, publisher, or printer for any infringement of copyright or otherwise, arising from the contents of this publication. Every effort has been made to ensure that credits accurately comply with information supplied. We apologize for any inaccuracies that may have occurred and will resolve inaccurate or missing information in a subsequent reprinting of the book.

10 9 8 7 6 5 4 3 2 1

ISBN: 978-1-63159-096-2

Library of Congress Cataloging-in-Publication Data available

The Zentangle® art form and method was created by Rick Roberts and Maria Thomas. Zentangle materials and teaching tools are copyrighted. "Zentangle" is a registered trademark of Zentangle, Inc. At the time of this printing, the Zentangle teaching method is patent pending. Learn more at zentangle.com Design: Sporto

Printed in China

CONTENTS

	Introduction4
	Zentangle in Practice6
	What Is Zentangle?8
Chapter 1:	BASICS AND ENHANCEMENTS14
Chapter 2:	TANGLES AND VALUE PATTERNS30
Chapter 3:	GEOMETRIC AND ORGANIC PATTERNS 46
Chapter 4:	UNDERSTANDING AND USING COLOR62
Chapter 5:	DEFINING AND USING STYLE78
Chapter 6:	CREATING THE REST OF YOUR ZENTANGLE JOURNEY94
	Appendix110
	Resources
	About the Author
	Artist Contributors

INTRODUCTION

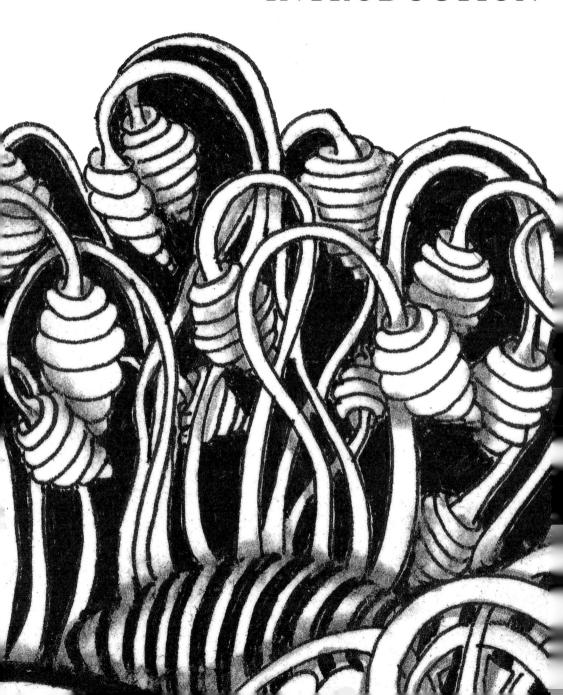

ORIGINS OF ZENTANGLE

The creators of Zentangle are Rick Roberts and Maria Thomas. He is the Zen and she is the Tangle. Rick has had many diverse vocations, such as cabdriver, high-tech sales and distribution positions, financial analyst, investor, Native American—style flute designer and creator, writer, recording artist, and for many years, monk. Maria is a renowned lettering artist and entrepreneur, owner of Pendragon Ink, a custom stationery and design company based in Massachusetts.

Zentangle is the combination of Maria's art background and Rick's meditation background. While watching Maria work one day, Rick noticed that her state of concentration kept her completely focused on her work. Through discussion they realized what Maria experienced while creating was what Rick experienced while meditating. Together they worked to create a series of steps that allow anyone to achieve a relaxed focus while they create beautiful images using repetitive patterns. By using repetitive patterns with deliberate strokes, one becomes engrossed in each stroke and a shift of focus—i.e., a heightened awareness in which your mind, instincts, and knowledge all work together quickly, effortlessly, and accurately—can occur. They call this a meditational art form.

What Rick and Maria call a meditational art form many artists or athletes would describe as being in the zone; a Yoga instructor would call this creating a sacred space; others would refer to it as having a relaxed focus. Not only is Zentangle a way of creating beautiful pieces of art, but it has added benefits to help us through the hectic pace of today's lifestyle. Studies show that this type of activity increases mental retention, stimulates creativity, improves one's mood, can be calming during stressful situations, and can be used as a tool for anger management. For individuals who deal with complex information,

practicing Zentangle resets the brain—as if you had a nap and woke refreshed. Zentangle teaches self-confidence through creating marks, designs, and freehand drawing and the eye-hand coordination needed for drawing.

These are quite a number of benefits when you consider a Zentangle takes only thirty minutes a day. In addition, you do not need to know how to draw because Zentangle will teach you. It does not require a lot of equipment, space, or technical ability. It can be brought everywhere and done anywhere, by anyone. No previous artistic ability is needed. Zentangle works for everyone.

ZENTANGLE IN PRACTICE

IN 2008. I WAS A TOURING ARTIST scheduled to teach in a different city over forty-seven weeks. The first show of the year, I was teaching at a national wholesale art convention. This show is always nerve-racking because of large class numbers and limited time to get everyone through the project.

I was limited in movement as I was tethered to the front of the room by a tenfoot microphone cord attached to the wall at one end, the other fed up the back of my jumper and attached at the front. I could barely reach the front row. As I stood, trapped, waiting for the class to start, I noticed Patty Euler, the owner of Queen's Ink, drawing on her instruction sheet. Her drawing was beautiful, and I told her that I did not know that she could draw so well. She replied, "This is Zentangle. My customers love it." She gave me a demo and promised to show me more when I came to teach at her store in a few months. The class went well, the rest of the week was very busy, and Zentangle fell to the back of my mind.

Fast-forward two months later. I woke up in a hospital recovery room. I learned that a life-threatening illness had returned. I put my busy career on hold as I began treatment. As I had been through this illness before, I knew what to expect, and that made my nerves harder to control.

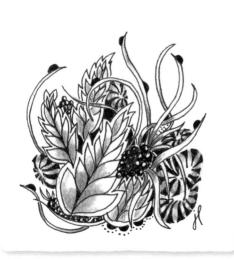

I lay in the hospital bed attached to tubes that prevented me from moving. Feeling trapped, I remembered the convention, Patty, and her drawing, which I thought would be a great project to keep my hands busy. I wouldn't need many supplies, and it would work in my limited space. Because the drawings were small, my attention span short, and my movement restricted, it seemed the perfect answer. At first I could not remember the name, but it did not take my friends and family long to retrieve it for me-Zentangle. They printed all they found about it on the Internet and brought it to me with pens and a sketchbook.

Black tiles have a style and elegance all their own.

I was surprised on the first day at how the time flew when I was "tangling." From that day forward. I drew Zentangled tiles to get through appointments, tests, surgery, hospitalizations, and treatments. At first, it was an easy kit to grab and go. It was small but efficient in keeping me occupied when I felt trapped. It did not take long to realize that it wasn't just the process of tangling that helped me through my illness, one step at a time. Often, fellow patients would ask what I was doing, and I would show them. I started bringing extra tiles and pens to share. One day, one of these patients said, "No wonder you are so calm and upbeat when I see you—this should be part of everyone's recovery."

I soon realized that if creating Zentangles could get me through the worst of times, it would also enhance the best of times. As I healed and was able to return to my studio, I replaced the former random routines I had used to focus with

drawing a few Zentangle tiles. Within ten to twenty minutes, I am focused and ready to work on my current project. In thirty-two years as a studio artist, I had never found a way to place my mind so quickly in what many call "the zone." To me, this means a state of focus that allows the instinctual and intellectual sides of the brain to work in harmony. The process of creating a Zentangle is a great tool. Creating Zentangle tiles fills your life with beautiful pieces of abstract art, improves drawing skills, and benefits the body and mind. Today there are many studies that point to the benefits of meditative art forms. From a reset similar to a nap, they calm the mind, increase the intake of information, sharpen focus, and relieve stress. Every correspondence I send ends with the phrase, "Keep creating, it will change your life." Not only does creating add beauty to your life, but it improves our attitude and personal outlook.

WHAT IS ZENTANGLE?

A ZENTANGLE IS A MINIATURE abstract work of art created from a collection of patterns not meant to represent anything. It is created on a 3½ x 3½-inch (8.9 x 8.9 cm) piece of art paper called a tile. This size allows it to be completed in a relatively short time. The process is a meditative art form, using a pen and pencil. There are no mistakes in Zentangle, so there is no need for an eraser. If you do not like the look of a stroke you have made, it then becomes only an opportunity to create a new tangle or transform it using an old trusty pattern.

A Zentangle tile is meant to be a surprise that unfolds before the creator's eyes, one stroke at a time. Zentangle is one of the few art forms that you intentionally do not plan out. There are no expectations or planned goals of accomplishment to worry about attaining or disappointments stemming from unattainable expectations. With no plan to follow, there is nothing to detract from the stroke being drawn. The lack of planning and the tangles allow the unexpected to occur.

The Supplies Needed to Create a Zentangle Tile

See page 22 to learn these tangles.

Try to use the best materials possible because your work is worth it, and it makes a difference in the quality of work you do. If you work on a piece of scrap paper, the paper has been deemed junk, so there is no concern about the quality of work done on it. A lack of focus results in work being sloppy, random, and careless. When we pick up a piece of quality art paper, our senses are awakened by the feel of the paper. We appreciate its weight, texture, and aesthetic. Our attention has been shifted from the world around us to the project before us. Because the paper has worth, our attention turns to focusing on creating each stroke and the piece of art before us.

ZENTANGLE TILES

A Zentangle is always created on a 3½ x 3½-inch (8.9 x 8.9 cm) tile. The official and original Zentangle tiles are heavy, have a deckled edge, and are created from an Italian-made paper, Tiepolo by Fabriano. Tiepolo is used by printmakers around the world. It is a thick paper with a 240-lb weight. and it has a definite weave to its surface. The woven texture causes you to slow down as you draw, thus giving you more control of the pen.

You know you are using an official tile because the back has a red square with an original Zentangle printed beside it. There are two lines also printed on the back. These can be obtained from your local Certified Zentangle Teacher (CZT) or from www.zentangle.com.

To create your own, use a parent sheet of good-quality art paper, of a heavier weight from your local art store. Measure and then tear or cut the paper into tiles. Use a pigment ink 005 pen to create the two 11/2 inch (3.8 cm) lines on the back. You will need a total of seventy-five to one hundred tiles to complete the daily Zentangle exercises, and you may choose to do some of the daily ZIA (Zentangle Inspired Art) on the tiles.

Black Zentangle Tiles

The black tiles are created from heavy black drawing paper. Tangles on these are created with white pens, and highlights are added with white chalk or colored pencil. Create your own by cutting or tearing black drawing paper into the same size as Zentangle tiles. Ten should be enough.

Zendala Tiles and Artist Trading Cards

The same art done on a 4½-inch (11.4 cm) round is called a Zendala, which comes in the original white. An artist trading card (ATC) is $2\frac{1}{2} \times 3\frac{1}{2}$ inches (6.4 x 8.9 cm) and is a wonderful platform for creating Zentangle Inspired Art. They come in

both white and black. Zendala tiles and Zentangle artist trading cards are available from your local CZT or online. If you are creating them, use the same paper you choose to create the Zentangle tiles. For the Zendalas, cut 4½-inch (11.4 cm) circles. For the ATCs, cut or tear the paper into $2\frac{1}{2} \times 3\frac{1}{2}$ -inch (6.4 x 8.9 cm) cards. Use a pigment ink 005 pen to draw two 1½-inch (3.8 cm) lines on the back of each tile or card. Ten ATCs and six Zendalas should be enough.

M ARTISTICO WATERCOLOR PAPER

This paper is sold in a parent sheet at the local art store or online. Artwork done on other sizes of paper is called Zentangle Inspired Art. or ZIA. Purchase this in the parent sheet, which is 22 x 30 inches (55.9 x 76.2 cm) and then tear or cut it to the desired size.

PIGMENT INK DRAWING

Zentangles are created with a size 01 pigment ink drawing pen in black. These pens give a beautiful dark, black, consistent line. You need only light hand pressure when using these pens. Hard pressure will result in ruining the tip and the pen. When the pen moves across the paper, the tip should feel like it is moving freely, though you may feel a slight drag from the texture of the paper. Keep the cap tightly on the pen when not in use to preserve the life of the pen. These pens come in sets or can be purchased individually. Look for drawing pens that contain pigment ink, which won't run when used with watercolors or gouache. The type of ink used in the pens will be listed on them.

Use white and black gel pens, a white Soufflé pen, and a white Glaze pen for tangling on the black tiles.

2H AND 2B PENCILS AND PENCIL SHARPENER

Drawing pencils are numbered according to the hardness or softness of the lead in the pencil. A 2H pencil has a harder lead than a 2B pencil and will leave a lighter mark than the graphite of the 2B. Get a simple art pencil sharpener. The pencil is used to create the shading on the Zentangle tile after all the tangles have been drawn. You will need a properly sharpened tip for this job.

White Pastel Pencil, Stabilo CarbOthello #1400/400 White or Koh-I-Noor Triocolor 31 White

This white charcoal pencil from General Pencil Company is used for creating Zentangles on the black tiles.

■ SKETCHBOOK

A sketchbook is needed for practicing tangles each day. Use the sketchbook in this kit and supplement as desired. Make sure the sketchbook paper is made for ink and thick enough that the ink will not bleed through to the pages below. Keep the size manageable. At times, we will take the sketchbooks with us to find new patterns. I prefer the 4 x 4 inch (10.2 x 10.2 cm) or 5 x 8 inch (12.7 x 20.3 cm) size.

SMALL TABLET OF BRISTOL VELLUM ARTIST PAPER

The smooth surface of Bristol Vellum artist paper is great for drawing on when using pencils, pens, colored pencils, and markers.

The Supplies Needed to Create Zentangle-Inspired Art

GEL PENS

I use mainly gel pens, which work on most papers even glossy, nonporous surfaces, and photographs. The pens come in great colors that cover well. Soufflé, a more opaque set, works great on black and white papers. Moonlight, Metallic, Gold Shadow, and Silver Shadow work well on both white and black papers. The Glaze set is the most translucent, followed by the Stardust set. which has fine metallic added. Pick up a set or purchase them individually. Choose pens that will work on both light and dark papers.

Neutral Color Brush Set by Pentel

This set has black, gray, and sepia pens. It also comes with a water brush and is great for working at home or in the field. Replacement barrels

come in open stock when the pen runs out. These pens create great wash drawings and paintings.

■ SMALL SET OF WATERCOLORS

The projects using watercolor in this book are done using Daniel Smith watercolors and/or a small travel set of watercolors. For beginners, these sets come in eight, twelve, eighteen, or twenty-four colors. The watercolor is vibrant. The kit comes with a brush that has its own water reservoir in the handle, making it great for working out in the field as well as at home.

Gelatos by Faber-Castell are paint sticks that are opaque. They mix with water, gel medium, matte and gloss medium, and gesso. They work on paper and fabric. Gold Gouache by Finetec comes in a set with several metallic colors.

Aquatone Water-Soluble Watercolor Sticks

These watercolor sticks are woodless, give great coverage, and come in twenty-four vibrant lightfast colors. They are also available in open stock so you can select what you want. Also consider using Sakura Koi watercolor brush tip pens.

INKTENSE COLORED PENCILS

These colored pencils combine the intensity of a pen and ink with the versatility of a drawn line of a painted wash. The colors are translucent and vibrant when used dry or wet with a brush. They come in sets or individually. They are permanent when dry and work well on textiles.

WATER-SOLUBLE WAX PASTELS

These work like cravons and can be used either dry or wet with water to create beautiful washes. Projects in the book used Caran d'Ache. They come in sets or individually. If you buy them individually, store them in a plastic pencil box because they can get on anything they come in contact with.

■ WATER-SOLUBLE OIL PASTELS

These work like the wax pastels but have a different texture. Their creamy consistency makes them easy to dry-blend as well as to dissolve with water into a vibrant watercolor. The projects in the book were completed using the Cretacolor set.

ALCOHOL-BASED INK MARKERS

Each of these markers has a chisel end and brush tip end, come in incredible colors, and are versatile to use. The markers will last a long time provided they are kept capped when not in use. They come in sets or can be purchased individually. Select a small, twelve-color set or create your own

by getting three primary and three secondary colors and a blending pen. Optional: The markers have an airbrush system that uses the pens. There is no messy cleanup, and the easy color change of just changing the marker make it one of my favorite tools. I use Liquid Pencil by Derivan in the tube Grey 3 and ArtGraf watersoluble graphite for shading drawings.

AMPERSAND CLAYBORD

This is a hardboard surface that has been prepared with a clay material. Claybord comes in a $3\frac{1}{2} \times 3\frac{1}{2}$ -inch (8.9 x 8.9 cm) size with four per package. It also comes in artist trading card size—a great platform for mixed-media ZIA. It would be good to have a pack of the $3\frac{1}{2}$ x $3\frac{1}{2}$ -inch (8.9 x 8.9 cm) size or a package of ATCs. Mica is available at some art stores or online from Dan Essig. Light colors work best for the drawing techniques in the book. Try Susan Lennart's ICF Resin or Gel Du Soleil resin.

In addition, you will need:

- A $3\frac{1}{2}$ x $3\frac{1}{2}$ -inch (8.9 x 8.9 cm) piece of Plexiglas—the width is less important than the thickness: it should be at least \(\frac{1}{8} \)-inch (3.2 mm) thick.
- Gum arabic (a watercolor medium) and a small iar
- A protractor (the kind that holds a pencil so you can switch from graphite to an ink pencil)

GETTING STARTED

Zentangle can really be done anywhere, as long as you can hold your tile, pencil, and pen. I always have a mini kit in my purse in case I feel inspired, need to alter my mood or stress level, or want to alleviate boredom. Tangling on the run is a great idea for getting through the events of daily life while bringing a little beauty to each day, but it's not the ideal way in which to learn a meditative art form.

To get the most out of your Zentangle journey. create a time and space where you can spend thirty minutes creating your daily Zentangle tile. Find a space you enjoy being in. The area should be free of interruption.

The art evolves from a border, string, and tangles that are drawn on the tile.

First, a pencil is used to draw a dot in each corner. The dots are connected by a line to create a border. Next, the string is created with the

Shading only adds to the design if there are tonal contrasts between shaded and nonshaded areas

pencil. A string is an abstract shape that divides the area inside the border. These divisions are filled with tangles that are drawn with a pigment ink drawing pen. Tangle patterns are made from a series of repetitive, easy-to-create, deliberate pen strokes. The process is very rhythmic, centering. and relaxing. By following the same steps each time, a ritual is created. The eleven steps are as follows:

- 1. Relax, stretch a little, and make yourself comfortable.
- 2. Breathe—take a few nice big breaths in and out. Smile. Remember to enjoy being in the moment.
- 3. Examine and admire your tools and your paper and appreciate this time to create.
- 4. With your 2H pencil, create a light dot about ½ inch (6.4 mm) in from each of the corners of the tile. There's no need to measure; just place them where it feels right.
- 5. Using the 2H pencil, draw a line from dot to dot creating a border. Don't worry about it being straight because the eye finds curved lines more interesting.
- 6. Create a string. The string creates a division of areas in which to lay tangles. It is the creative map of your daily Zentangle journey. The string can be any shape, size, or on any spot inside the square and doesn't have to be a continuous line. Not every section of the string has to be filled with a tangle. If instinct tells you to leave an area blank, then follow

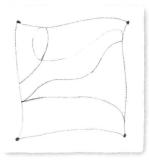

Steps 4 through 6 are spontaneous and generally created quickly. Like fingerprints, no two strings should ever be the same.

your gut. The string is meant to dissolve away into the background of the finished Zentangle like an invisible border or edge. Never draw the string in ink because then it creates a border that becomes the focus, much like the effect found in a coloring book. It is no longer a suggestion; the string is now a rigid border that limits the options for placing tangles.

- 7. Pick up your pigment ink pen. Turn your tile and examine the pattern that the string makes from each angle. Hold it out at arm's length so you also see the composition from a distance. Following your first impulse, start filling in each section of the string with the tangles learned that day. Do not overthink your decisions and do not hurry. Be deliberate and focus on each stroke. Turn your tile as you work to make it easier to create your design.
- 8. With your 2H or 2B pencil, shade your tangles. In the beginning, we will shade the tangles by using the side of the pencil around the edges of each tangle and then smudging

- it with our finger. This type of shading should be darker toward the edges, lightening as it comes into the tangle to control the amount of gray used. Shading is not effective if the whole piece is gray.
- 9. Once again, turn your tile and view it from each angle. Decide how you wish the piece to be viewed. Using the pigment ink pen, place your initials on the front of the tile. Turn the tile over and sign your name and date the piece. Add any comments here, like where you were, with whom, or if it is a particular event that day that this Zentangle honors.
- 10. Reflect on your piece of art.
- 11. Appreciate and admire your piece, not just up close but also from 3 to 4 feet (0.9 to 1.2 m) away. It is amazing how the piece changes from a distance. You can find a quick reference for the 11-step Zentangle process on page 111 in this book and on the second page of the sketchbook in this kit. Tear out the page from the sketchbook and keep it on your desk for easy reference.

BASICS AND ENHANCEMENTS

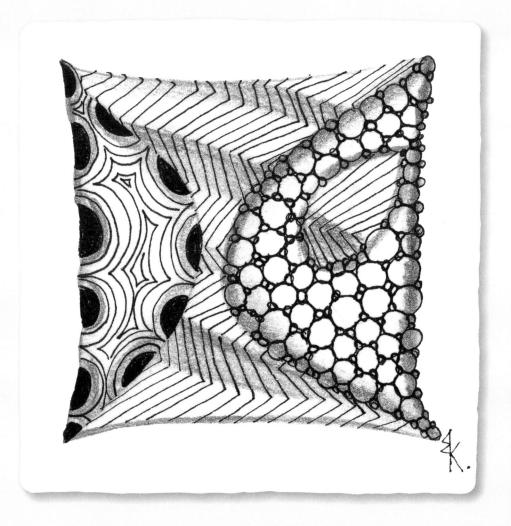

EACH DAY WILL START with learning new tangles. The patterns will be diagrammed in a series of 1-inch (2.5 cm) squares numbered in order. The new step is drawn in each square in red ink. The last box of each diagrammed pattern contains one example of how to shade that pattern.

Every day, the directions will call for you to practice the new pattern before creating a Zentangle using the pattern. Some readers will copy the diagram steps for each pattern and then start re-creating the patterns in the sketchbook until comfortable with creating them. Others learn better by drawing only the pattern and then practicing it a few times.

Either way is fine; do what feels most comfortable to you. Label each tangle with the pattern name for later reference. Each tangle is given a name when created. This makes them identifiable and easy to reference.

Think of the sketchbook as a workbook to use to become familiar and experiment with the tangles. It is also a source for quick reference to remind you how a pattern is drawn, what has worked for you, and what has not. Being familiar does not mean you have to have the patterns memorized; it just means you have tried them out, paid attention to how they are created, and worked out any kinks you came across as you learned the pattern. It is okay to refer back to the diagrams at any time.

project to introduce you to new techniques or ways to include Zentangle when creating art.

These projects include Zentangle Inspired Art (ZIA) and Zendalas, which are a form of a mandala.

Mandalas are steeped in meaning from the colors to the patterns used. They are circular art forms often created in a meditative fashion. A Zendala does not contain meanings in the patterns or colors, but is a meditative art form. Zendalas are created using the same tangles as the Zentangle tile.

On some days, there will be an additional

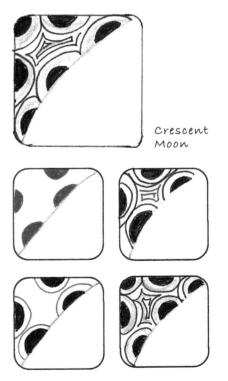

There are no mistakes in Zentangle, no need for erasers.

GETTING ACQUAINTED WITH YOUR TOOLS

MATERIALS

- 01 pigment ink drawing pen
- pencil
- sketchbook
- # tile

THE FIRST PROJECT is designed to give you the opportunity to become acquainted with the use and feel of the Micron pen while creating the mark that identifies a completed tile as your own. When a Zentangle tile has been completed, the creator first signs the front of the piece with his or her initials in ink, which becomes the signature on the front of the tile. Small, uniquely stylized, and individual, the signature represents the unique artist. Each Zentangle artist is encouraged to spend time creating this signature. Practice using the 01 drawing pen as you create a stylized signature from your initials. Remember to use light hand pressure when using the pens, because heavy pressure will destroy the tip of the pen. You will have better control if you pull the pen toward you as you create the pattern strokes.

DAILY TANGLES

Try these three tangles. The Static tangle is an easy tangle to start with, but try to keep the spacing between the lines even. For the Tipple. do not worry about creating the circles all the same size. To produce nice round orbs, slow down and focus on the stroke. When creating the Crescent Moon, even spacing on the halfmoons helps create a feeling of balance.

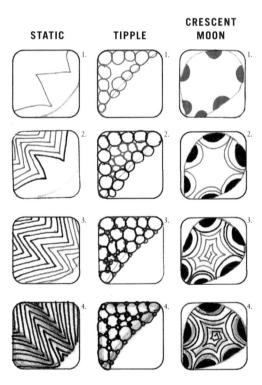

Practice these tangles in your sketchbook.

Make a pattern with your initials. Have fun with this exercise—be spontaneous and experiment with the types of marks the pen can make.

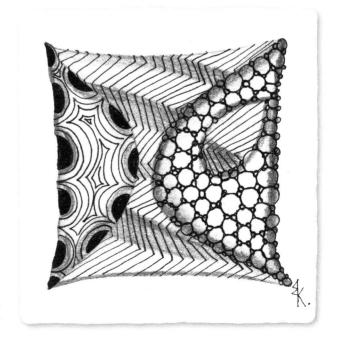

Sample of Zentangle using Crescent Moon, Tipple, and Static

PATTERN AS TONAL VALUE

MATERIALS

- 01 pigment ink drawing pen
- m pencil
- sketchbook
- m tile

EACH TANGLE HAS a tonal value. Tangle patterns can be mixed together on a tile to create a variety of interesting values. Values, for our purposes, are the shades of black, white, and gray that each tangle contains. The intensity or amount of light or dark a value has is referred to as tone. Tonal values are created or changed by altering the amount of white space versus dark space in a tangle. Placing the pattern closer together along the edges creates a darker value on the edge. Opening the center of the same pattern adds to the illusion of form and helps create depth. The altering of a tangle creates the illusion of different tones on a Zentangle tile. It creates form, shape, highlights and/or shadows, and interest. and it helps to move the eye through the piece. This is a great technique for adding form and creating shape.

DAILY TANGLES

Try these three tangles. Knights Bridge Tangle can be drawn as both a square checkerboard or a diamond-shape checkerboard. Nekton and Fescu Tangles can be made open and airy by keeping the spacing wider between the lines in the pattern. They can be made denser and appear darker by placing the lines closer together. Practice these patterns in your sketchbook until they feel familiar.

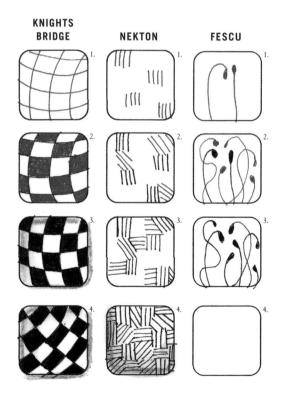

THE STRING

The string is the foundation of our Zentangle, but it is just a suggestion. Use it when and where you want to. The string is the only part of creating a Zentangle that is spontaneous. There is no plan in spontaneity. If the body is relaxed, the pencil can move freely across the page to follow a whim or creative spark or fill an empty area.

The sketchbook is a great place to practice creating strings. Turn to a new page in your sketchbook. Use a pencil to create four dots in a 21/2-inch (6.4 cm) area. Connect the dots and draw a string. Fill the page with strings. Try creating curvy strings, straight and angular strings, and combining the two. Changing how you hold the pencil can also make a difference. Try several positions to find out what works best for you.

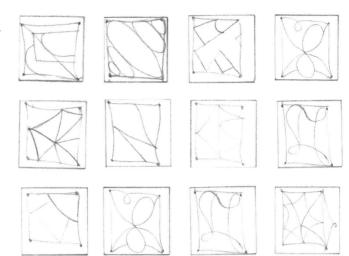

Like fingerprints, no two strings are the same.

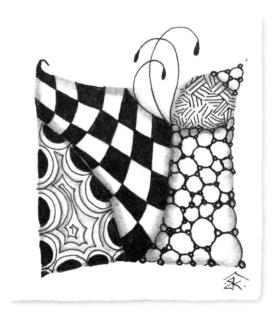

The border and string are elements that you can choose to use in full or ignore.

Using the eleven-step process (see page 111), create a Zentangle tile with the three new patterns and any of the patterns previously learned.

OVERLAPPING DESIGNS TO CREATE DEPTH

MATERIALS

- 01 pigment ink drawing pen
- m pencil
- sketchbook
- # tile

SOME PATTERNS NATURALLY lend themselves to creating depth, especially when the pattern is overlapped and repeated until the area of the string is full. This gives the impression that the pattern is receding away. Refer to the diagram below. To create this effect, I draw a tangle once. See box 1. Think of this pattern as now being opaque (i.e., nothing should show through it). Repeat the pattern, but lift the pen off the paper when you come to the first drawn pattern. Continue the pattern with the pen in the air until you reach the other side of the first pattern where the rest of the new pattern should appear. See box 2. Do not draw on top of the original pattern or the new one created behind it. Consider the patterns in the front opaque, blocking out all beneath it. Repeat until the string area is full. See box 3.

Drawing tangles overlapping one another and using this approach as a way to intermingle two different tangles can be seen historically in Zentangle since its earliest concept.

DAILY TANGLES

Try these three tangles. The patterns for the Poke Root, Festune, and Hollibaugh tangles become smaller as they recede, adding greater depth. Or, you can achieve a very organic ascending look by keeping them all close to the same size. Practice these patterns in your sketchbook until you are familiar with them.

ENHANCING ZENTANGLES

Tanglenhancers add interest for the eye, and each one has aspects that make them a handy tool. Zentangle has six Tanglenhancers: auras, dewdrops, perfs, rounding, shading, and sparkles. Shading is a Tanglenhancer used on all our patterns to create depth, dimension, and form. On patterns that contain orbs, such as Poke Root, shading can help create a three-dimensional effect. Refer to the last tile on the Poke Root. pattern on the diagram. Take a moment to study the drawing. Notice the shadows on the patterns that fall behind. The slight shading creates the impression of depth and leads the eve into the background. The smile-shaped shading on the front of Poke Root's orb fools the eye that the tangle is puffing forward off the page. The Festune pattern has a shape resembling a tire, so the shading should run along the bottom front to create the impression of dimension and weight. The casted shadows drawn on each pattern that are behind a previous pattern lead the eye through the piece. Tangle patterns are not meant to look like anything, but sometimes they do. The Hollibaugh pattern looks like a stack of boards

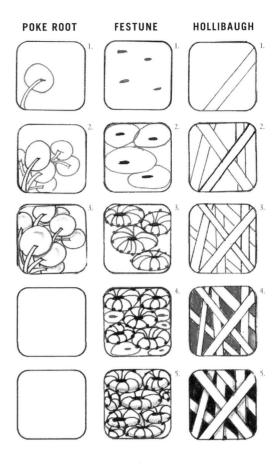

from above. Shade the sides on the patterns only where one board seems to be running behind another. As you become familiar with new patterns each day, take note of the examples of shading in the final diagrammed box of each pattern. They will contain tips for shading the pattern throughout the rest of the book.

ORB OR HOLE, ONLY THE SHADING WILL TELL

MATERIALS

- 01 pigment ink drawing pen
- m pencil
- sketchbook
- m tile

DAILY TANGLES

TRY THESE THREE TANGLES: Shattuck, Nipa, and Jonqual. Nipa is the first pattern we are learning in which you can treat the circle as a hole or an orb. Shattuck and Jonqual are angular patterns. For best results, focus on keeping the spacing even between the strokes on each of these patterns. Remember to turn your tile as you change angles while drawing patterns such as Shattuck so you can create your strokes more accurately and comfortably. Practice each of these patterns in your sketchbook until they feel familiar.

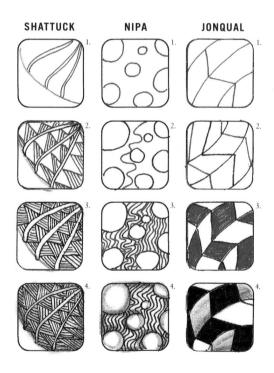

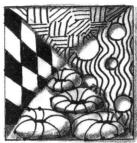

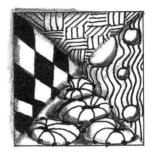

By picking a light source, shading becomes natural and there is no need for decisions.

EVEN THOUGH OUR ZENTANGLES are abstract pieces of art, shading is still a very important part of the art piece. Shading draws us in. It helps move the eye through the piece. Shading makes the dips, curves, edges, and angles in our artwork believable. It can be used to add atmosphere, weight, and tonal contrast, and it can make an unrecognizable world seem familiar and inviting. While shading, pick an area to use as the light source. If the light is coming from the upper-left area, the shadows will fall toward the lower-right sections of the patterns. If the light source is coming from the lower-left area, the shadow is cast toward the upper-right sections.

Create a sample tile on a clean page in your sketchbook using any three or four tangles. Select a direction for the light source for each sample and shade accordingly.

ADDING A SPARKLE

MATERIALS

- 01 pigment ink drawing pen
- m pencil
- sketchbook
- m tile

A SPARKLE IS A GREAT description of a highlight and is another Tanglenhancer. A sparkle is created when you leave a deliberate gap in a stroke while creating a tangle. As you are drawing out a tangle stroke, pause and lift your pen, leaving a slight gap in the stroke before placing the tip back on the paper and finishing the stroke. Creating highlights in a drawing in this manner is reminiscent of the highlights found in old ink drawings and engravings. Sparkles add light to your tangles, a small flicker to capture the eye and entice the viewer. Isochor and Printemps are two tangles that traditionally contain highlights. You can use a highlight in any tangle you choose, not just those traditionally containing them. Where the highlight is placed will affect where the shading is placed.

DAILY TANGLES

Try these two tangles. Printemps is a closed coil. Slow down when drawing this pattern so you can keep the area between the lines of the coil even. gradually tapering the space down to close the coil. While filling an area of a string with Printemps, the sparkle should always appear in the same place on each coil, and not every coil has or should have a sparkle. Just like the shadows, the highlight can be overused and the contrast lost. A pattern drawn in the round, such as Printemps, has the shadow placed on the side of the coil without the sparkle. Drawn images are ink and graphite on flat paper, but adding highlights and shadows to the images gives the appearance of dimension and form. Isochor uses lines to bring volume to an area. Altering the direction of the lines in areas falling behind an area that also uses Isochor helps the eye take in all the line movement and creates depth.

Practice each of these patterns in your sketchbook until they feel familiar.

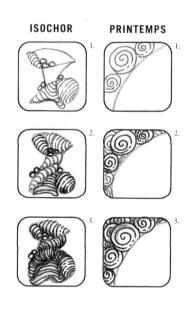

Treat a sparkle as a small light source. There should be no shadow inside the sparkle and a small area around it.

SPARKLES ARE USED to add appeal to a repeating pattern. They bring interest to a tangle that could become monotonous, especially in an area that uses a one-stroke pattern repetitively over a large area. Go back to the previously learned patterns in your sketchbook. Study the diagrams and imagine where in each pattern you see a place a sparkle could go. In your sketchbook, create a sample of a few of the patterns with sparkles added to them. Don't forget to shade them.

Glance over the eleven-step process for creating a Zentangle tile and then use the steps to create a Zentangle tile that includes Isochor, Printemps, and any previously learned tangles you choose to use.

Samples of previous patterns with sparkles added

Sample of a Zentangle using the Isochor and Printemps tangles

ONE-STROKE PATTERNS

MATERIALS

- 01 pigment ink drawing pen
- m pencil
- sketchbook
- m tile

ONE OF THE PREREQUISITES to a design becoming a tangle is that it be completed in a few strokes. Some are completed in one stroke, many in two. Mooka, for example, is a pattern made from start to finish without lifting the pen, thus one stroke. Onestroke patterns are very effective in relaxing into any meditative art form. Quick to learn and easy to remember, one-stroke patterns are quick to find their way onto many tanglers' favorites list.

DAILY TANGLES

Try these three tangles. Amaze is a meandering tangle created from a meandering line that never crosses itself. Flux is one stroke repeated several times. The key to success when drawing Mooka is to slow down. Be deliberate in where you are moving the pen.

Practice each of the tangles in your sketchbook until they feel familiar.

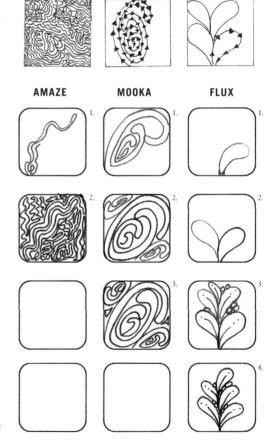

Diagrams of the Amaze, Mooka, and Flux tangles

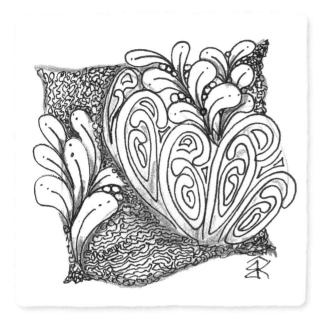

Review the eleven steps to the Zentangle process and then create a Zentangle tile using Amaze, Mooka, and Flux tangles. Any of the other patterns previously learned may also be used.

Amaze, being a denser pattern than the other two, creates a background for the lighter toned patterns of Mooka and Flux.

ON DAY 3, the approach of drawing tangles behind one another was covered. This technique is a great way to transcend from one pattern to the next. On that day, we worked with three patterns that used this concept. Other patterns such as Mooka lend themselves with slight alterations to this process.

Drawing one tangle behind a different tangle is a great way to change from one pattern into the next. A useful technique for dealing with awkward corners is to move the eye around the piece by changing from a busy tangle to a more open tangle or adding a pattern that will invoke some mystery.

Turn to a clean page in your sketchbook and practice this technique with a few of the patterns we have learned.

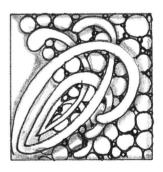

Sample of the Mooka pattern going over the Tipple pattern

TANGLEATIONS OPEN UP A PATTERN'S POSSIBILITIES

MATERIALS

- 01 pigment ink drawing pen
- m pencil
- sketchbook
- # tile

Tangleations of:

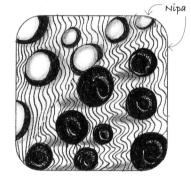

TANGLEATIONS ARE CREATED when an original existing tangle is varied or altered. On day 6, we created a Tangleation of Mooka by unfurling it outside of itself and adding Tipple into its negative areas. Alterations can be a change of shape, tonal value, altered foregrounds or backgrounds, or a combination of all of the above. Limited only by the imagination, the possibilities are endless.

Turn to a clean page in your sketchbook and try creating a few Tangleations from patterns you have learned. Create a step-out diagram for any pattern that might require a reminder to re-create.

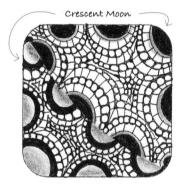

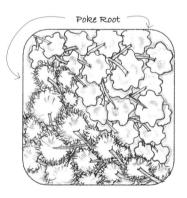

In the sketches, the darker areas of the original patterns for Knights Bridge and Hollibaugh are replaced with two patterns with a lighter tonal value, thus lightening the tonal

value of the whole pattern. Tangleations create the opportunity to alter a tangle so that it fits the atmosphere of the Zentangle tile you are creating.

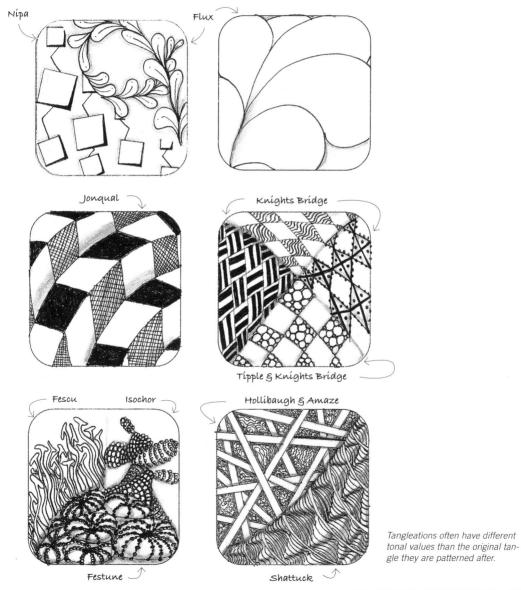

TANGLES AND VALUE PATTERNS

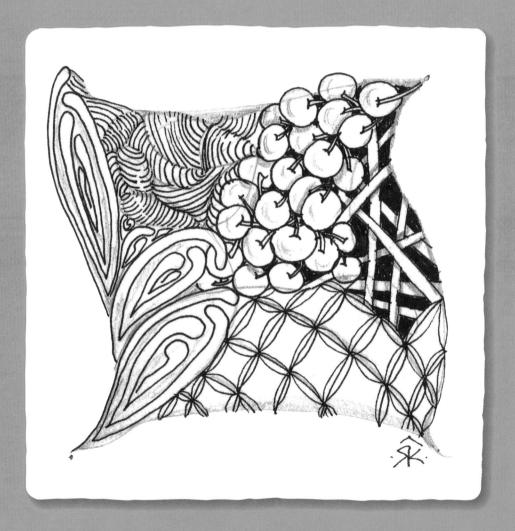

ARTWORK VIEWED FROM A SHORT DISTANCE allows the tonal values throughout the piece to subconsciously lead the eye throughout it. When viewing art, few people take note of these values, but their subconscious does. The subconscious picks up the pattern of tonal values and moves the eye throughout the pattern.

Zentangles are created from the achromatic colors white, black, and the endless range of gray that appears in the middle. Placing these values from lightest to darkest creates a tonal value scale. Create a tangle tonal scale of the tangles from chapter 1 on a sheet of Bristol yellum.

Place the patterns in a column, starting at the upper-left, with the lightest light tone—the high-key values. Place the darker tones in the right column—the low-key values. My sample, at right, ranges from the lightest value, Flux, to the darkest pattern value, Amaze.

A piece that uses high-key values will appear airy, inviting, or perhaps playful and energetic. A piece using mainly low-key values creates a dramatic atmosphere. Tonal mapping is a great tool to refer to when at a loss for which pattern to use next. Recognizing the tangle's tonal value ensures the pattern will bring harmony and the desired atmosphere to the design.

TONAL VALUE SCALE

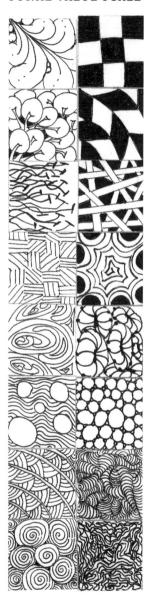

Remember to squint as you look at the tile. The tonal scale, center, appears like a map of shaded areas across the tile. This scale is called a value pattern. Right: Draw each pattern on a 1-inch (2.5 cm) square of Bristol vellum with a 01 drawing pen. Using repositionable tape, keep turning the tiles and consider the options for pattern placement.

FROM FLAT TO 3-D IN TWENTY MINUTES

MATERIALS

- 01 pigment ink drawing pen
- pencil
- sketchbook
- # tile

TONAL RANGES TURN A FLAT line drawing into a 3-D shape. Graduating the shadows from dark to light gives shapes volume. If the light source is from above, the light is stronger at the top of the pattern, making the shadows there lighter than those at the base of the pattern. Start the shadow in the darkest area and lighten up as you move the shadow out. Do not shade the whole area gray. The shadow has changed in tone, not size.

DAILY TANGLES

Try these two tangles. Vega can create a border or be used to overlap itself with interesting textural results. Turn your tile often when drawing this pattern or any pattern that changes direction. This ensures your hand is at the correct angle to maintain control as you draw each stroke. Much of the form of the second pattern, Purk, is established in its shape. The shading on the orbs of this tangle brings out the dimension.

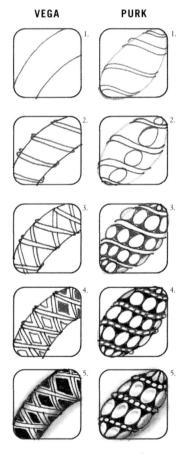

Both patterns have strong silhouettes; Vega's is low key, and Purk's is high key.

THE POSITIVE SHAPES are the focal points. They appear to be coming forward. Focal points obtain dominance by size, value, or hue to create contrast from the negative patterns surrounding them. Shading should be darker around the positive spaces to create depth. The negative shapes are the background shapes. Keep the positive and negative shapes from being fragmented by watching the tonal values in the shading. Use a thin, lightly shaded line to separate the high-key areas. In the low-key areas, use a thin highlight to separate the focal point from the background or cast shadow.

Light casts shadows differently on angular shapes. If you want the piece to remain angular, the shading must have straight edges. Shading a shape that is intended to look like it protrudes will be different than one that appears concave.

Shapes that resemble circles or ovals, squares or rectangles, or a combination of these shapes, such as a cone, are what a string is composed of. Shading works the same whether the circle is a realistic apple or an abstract orb.

In your sketchbook, create several strings that resemble shapes. Fill each shape with a tangle and then shade each area.

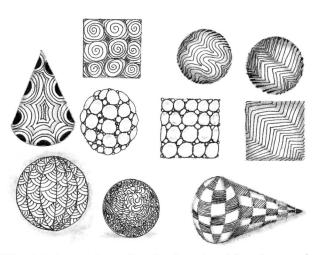

With only background shading, the bottom three shapes' dimension comes from varying the pattern density on each shape.

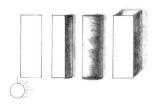

A shape without shading is flat. Shadows on rectangular and square shapes need to be sharp. The third rectangle appears round because of the organic edge of the shadow.

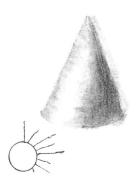

Notice the change in shading from the cone's base to its top.

WHITE TILES VERSUS BLACK TILES

MATERIALS

- 01 pigment ink drawing pen
- white gel pen
- white charcoal pencil
- white pencil of your choice
- sketchbook
- white tile
- black tile

ZENTANGLE TILES ALSO COME IN BLACK. White ink on black tile creates beautiful studies in light. Black Zentangle tiles are bevel-cut black drawing paper made from Arches black cover paper. Black tiles are created just as the white tiles, except you use a white pencil and pen. I use the Unibal white gel pen the most. I also use the Soufflé. The ink goes on wet and requires a short drying time before you can shade, so be careful not to smudge it as you work. Most gel pens have gloss ink; the Soufflé pens have matte ink. There are also Glaze gel pens that leave a glossy transparent line—the ink goes on milky bluish and dries clear. Typically, white highlights are created with a white soft pastel pencil, but I prefer to shade with the white colored pencil. Pastel pencil rubs out easily. It can smudge away from the surface of the tile if rubbed against anything. I do use the soft white charcoal pencil to draw the string on the black tiles, lightly so I do not create much dust. Whereas on the white tile the highlights come from the white of the

The first tile is done using the pigment ink drawing pen and pencil. The second tile is drawn with a white gel pen, shaded with a white colored pencil. The third tile uses a Soufflé pen and charcoal pencil for shading. The last tile is drawn with a Glaze pen.

paper, on the black tiles the shadow comes from the black color of the paper. We create depth on the black tiles by using a white pencil to create not just the highlights, but to graduate the highlight out to create form. The more pressure applied to the pencil, the greater intensity of white left behind. On a black tile, practice creating a graduated scale with each type of white pencil you have. Glue this tile into your sketchbook with notes on how each pencil performed for you.

PATTERNS WITH A high-key tonal value when drawn on white paper become a low-key value when drawn on black paper. Working on black paper with patterns created from a lot of line work such as Amaze shift to high key and the open patterns such as Poke Root are now low key.

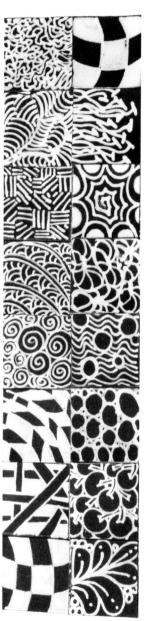

These are the same patterns used in the value scale on white paper (page 31). Only Knights Bridge is in the same spot on both scales.

LESSONS FROM A LANDSCAPE

MATERIALS

- 005 pigment ink drawing pen
- 01 pigment ink drawing pen
- 2H or 2B pencil
- sketchbook
- white tile

FINERY ECHOISM FLUKES ALTHOUGH WE ARE NOT going to draw a landscape, we are going to study how they are composed and then apply those principles to our tangled tiles. Compositional balance is achieved through a balancing act of shapes and their surfaces. Every shape has a visual weight. A shape's visual weight is affected by size, location, tonal value, background value, and emphasis on its contour. A familiar example of this is a landscape.

Depth is created in landscapes by gradually diminishing color and shapes as they recede into the horizon. The focal point is placed off-center in the forefront of the composition because it is closer to the viewer. It appears larger than the background shapes. Shading is darker and more defined on the focal point, while it fades with blurred edges that diminish on the background shapes. Physical weight anchors a composition and creates a visual balance with the light, airy atmosphere in the background. This effect can be used to create depth and compositional balance with the abstract shapes drawn on a Zentangle tile.

DAILY TANGLES

Try these three tangles. Finery is a very lighttoned tangle. For the best results, focus on spacing the lines evenly when drawing this pattern. Echoism moves the eye through a Zentangle tile. I think of it as an abstract path leading the eye through the piece. Turn your tile when drawing the grid for Flukes.

Artists' value scale is much narrower than that found in nature.

Contributing artist Angie Vangalis's background pattern decreases in size the farther it gets from the focal point. To enhance fading in the background, the areas near the focal point were started with a 01 drawing pen. As the pattern was almost two-thirds complete, she used a smaller-tipped 005 drawing pen.

CHANGING PEN TIP SIZES as we create patterns to enhance the illusion of depth is a simple technique that can be big on impact. There is very limited space on a Zentangle tile, so this technique can help keep a clearer definition of the patterns while enhancing the illusion of depth. On a clean page in your sketchbook, practice this technique with several of your favorite patterns and a few patterns you rarely use. Pay attention to the different line each nib creates and how they each affect the patterns' tone, weight, and shading.

All three examples move the eye through the piece by decreasing tonal values as they recede.

AURAS AND ROUNDING, TWO NEW TANGLENHANCERS

MATERIALS

- 01 pigment ink drawing pen
- 2H and 2B pencils
- brush pens in black and gray
- sketchbook
- white tile
- ATCs

TODAY WE WILL WORK with two Tanglenhancers that can also affect your tonal values. Auras are created by carefully drawing within $\frac{1}{16}$ to $\frac{1}{8}$ inch (1.6 to 3.2 mm) around a tangle's edge. This creates a line that mimics the shape's edge. Keep the spacing even all the way around; drawing slowly helps. You can create auras in multiples and even place patterns in them. Auras are great for transcending from one tangle or tonal pattern to another.

Rounding on a tangle refers to darkening the crevices, nooks, and crannies. It is a little detail that gives a finished, classic look to the tangle. Rounding is done with a pen. It brings dimension. weight, and depth to a piece and can be very useful in anchoring a pattern into the composition.

Create today's Zentangle tile using any tangles you choose. Use an aura around at least one tangled pattern and incorporate rounding on at least one pattern. Last, challenge yourself to also use one pattern you rarely use when you tangle. Add any other patterns you would like to complete your tile.

The auras help keep the patterns light and airy while the rounding in Poke Root, Mooka, and Tipple help anchor the composition.

THIS EXERCISE BRINGS OUR

AWARENESS to how much hand pressure we use when we draw. When you draw with a brush and ink, any change in hand pressure will show as a change in the width of the line. The more pressure that is placed on the tip of the brush pen, the wider the line. Concentrate on making consistent lines in this exercise. Turn to a clean

page in the sketchbook. Experiment with making short thin lines that are consistent in width. Then try thicker lines, wavy lines, and orbs. Practice several patterns using the pens. Use a brush and water to create shadows. When you are comfortable with the brush pen, try creating an ATC or two. Add auras and rounding when desired.

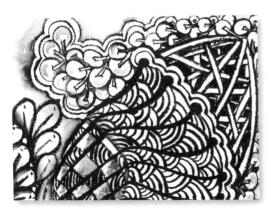

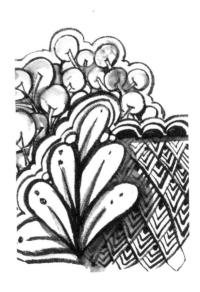

On the first ATC, I learned a lot and found that shading the patterns with the water required caution, especially in areas containing a lot of ink. I used some drips from the ink to add interest on the second ATC.

BALANCING HARMONY AND VARIETY

MATERIALS

- 01 pigment ink drawing pen
- m pencil
- sketchbook
- white tile

THE BALANCE OF HARMONY to variety in a composition creates eye movement. Harmony is created by a relationship between different areas on a composition that create a pleasing effect for the viewer. The relationship may be a similarity in shape, tonal value, size, or a combination of one or more. The common elements need not be identical, just close enough to visually link. If the pattern is too identical, it will become boring, and the viewer will lose interest. Some variety must exist in patterns to capture and keep the viewer's attention. Variety adds excitement and perks interest,

BEFLIGHT CHILLON BALES but if overdone it can leave a piece feeling too busy, heavy, cluttered, and disjointed. Any one of these feelings can overwhelm viewers, causing their interest to move on.

DAILY TANGLES

Try these three tangles. Beelight resembles an earlier pattern we learned, Flukes, so it works well to create harmony in pieces. Chillon and Bales are two patterns that also share a visual likeness. Practice these three patterns in your sketchbook until they feel familiar.

When you feel comfortable with the pattern, create a Zentangle tile using Chillon and Bales to create harmony in the composition. Choose patterns to use with Chillon and Bales that have enough tonal contrast to let them stand out.

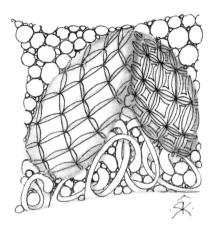

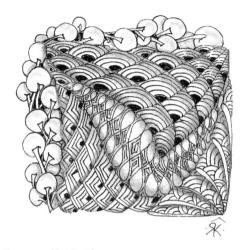

In both of these tiles, it is the likeness of a few patterns that tie the composition together.

TANGLEATIONS ARE ANOTHER WAY

to create this effect. Changing an existing tangle into one or two altered versions creates a visual link. The Tangleations must leave the tangles similar, yet create enough variety between the patterns to create interest and draw the viewer in.

Changing the size, shading, and tonal value of the Beelight tangle creates two Tangleations that are visually linked. The patterns contain enough variety, when sprinkled among other patterns on a tile, to capture the viewer's eye and interest. The same goes for the Tangleation of Bales. Practice these Tangleations in your sketchbook. You might want to place them on the page on which you diagrammed the original patterns so they are easy to reference later.

From left to right: two Tangleations of Beelight, one of Bales. These patterns are a great example of a small change in a pattern that creates a whole new look. Opening up Beelight changes its tonal value. Then by going further and adding another colored tip, the dimension changes. Coloring in half the center diamonds on the pattern Bales and adding shading give the illusion that the pattern now ripples.

DECONSTRUCTING AND RECONSTRUCTING A PATTERN

MATERIALS

- 01 pigment ink drawing pen
- m pencil
- blending stump
- sketchbook
- white tile

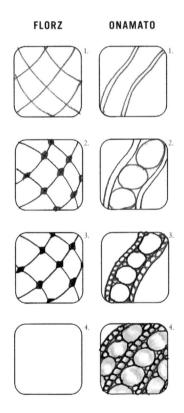

DECONSTRUCTING IS DRAWING an area of a tangled pattern to appear to have come apart. The parts of the pattern can appear to be falling gracefully away, torn, or transformed into a new pattern. This creates drama for the eye and a surprise to pique the viewer's interest and gives the art piece a story. Using this technique as it approaches another pattern is a great way to bridge patterns together. When used in the middle of a pattern, it can lighten the tonal value of a busy area or change the feel of weightiness. Deconstructing a pattern creates endless opportunities for transcending from one pattern to another. The broken pieces of a pattern can be drawn on a pattern's edge to resemble the pattern falling apart and the pattern ending there. Or the broken edge pieces can be used to start the new pattern, morphing one into another pattern. Wherever this technique is used on a Zentangle tile, it will move the viewer's eye and create a surprise element for the eye to find.

DAILY TANGLES

Try these two tangles. Florz and Onamato are two patterns that lend themselves well to this process. Florz is usually drawn on a diagonal with the original grid in diamond form, but it also can be drawn in checkerboard fashion. Onamato's many orbs give it a nice textural effect. This pattern works well for adding depth in areas. It can easily be drawn smaller as it recedes. Practice the new patterns in your sketchbook until they are familiar.

KNOWING THE PATTERNS MEANS you know how to re-create them. Many patterns lend themselves to deconstructing or morphing into another pattern. Practice deconstructing and/or morphing some of the previous patterns we have learned on a clean page in your sketchbook. The combinations learned in this exercise will be useful for incorporating this technique in future tiles you tangle.

Each of the drawings Judy did started from one pattern that transforms or deconstructs and reconstructs into a new pattern. The top left image began with Isochor, the top right image began with Nipa, and the bottom image began with Hollibaugh.

DECORATIVE VALUE

MATERIALS

- 01 pigment ink drawing pen
- white gel pen
- white charcoal pencil
- white chalk or colorored pencil
- 2B pencil
- sketchbook
- white tile
- black tile

DYON CHAINGING **KEEKO**

CHILDREN'S ART IS A PERFECT example of decorative value, which uses no established light source. Art pieces using the decorative value technique for shading feel shallow and have little depth. Decorative values can be maximized on a tile to move the eye through the piece with shapes that interact and shadows that create planes. To create this effect, the shape closest to the viewer is lightest in value and is referred to as the first plane. The shapes that lie directly behind the first plane and border its edges are given a slightly darker tonal value and make up the second plane. The shapes behind the second plane are shaded darker. Each plane of surrounding shapes gets darker as the planes descend outward. The amount of descending planes is kept to two or three layers to maintain the shallow feel. Conversely, you can start with the top plane shaded to the darkest tone, making each descending plane lighter.

Create a white Zentangle tile using the eleven-step process (see page 111) and today's tangles. You can use any of the patterns or a Tangleation of previously learned patterns.

DAILY TANGLES

Try these three new tangles. The pattern Dyon is interesting whether you use it as one large Dyon tangle or as a grouping of the pattern. You can use Chainging as a border or in small, irregular spaces. It is easy to incorporate into awkward areas such as corners. The tangle Keeko is lively and a feast of movement. When drawing Keeko, start with the horizontal lines on each row first and then connect with the vertical lines. The lines can be drawn straight or with a slight curve.

DECORATIVE VALUE WORKS WELL

with tangles on black tiles, as shown below. The contrast between the black paper and white ink pops the tonal values of each pattern. On a black tile, use a white pen to create a Zentangle using decorative value. Use the tonal value of the patterns to decide where they are placed on the string. The lightest should be on the front focal point. As shapes get farther from the focal point, their tonal values slightly darken.

Because we are limited to graduated highlights and no shading when drawing on black tiles, the shallowness of decorative value works to create depth and to keep the eye moving and focused. Too many layers on the black tiles can easily create a cluttered puzzle of planes that all read the same.

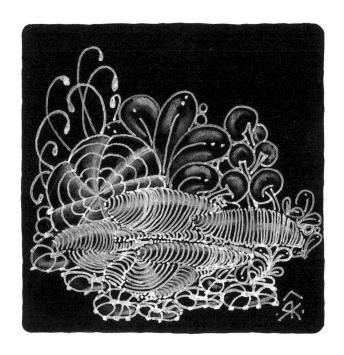

GEOMETRIC AND ORGANIC PATTERNS

THE ART DRAWN on a Zentangle tile is a combination of tangles and shapes that can be broken down into geometric or organic styles or a combination of the two. Geometric shapes are precise, orderly, often sharply defined, or appear mechanical in nature. They can be characterized as curvilinear, made with curved lines like circles or ovals, or rectilinear, shapes made from straight lines. Printemps is an example of a curvilinear pattern. Hollibaugh and Rick's Paradox are great examples of rectilinear patterns. Organic, or biomorphic style, as it is also termed, has curved, free-formed lines. They may have edges that can be rounded or undulating, and they have a natural look and feel. Flux and Fescu exemplify the organic style.

In the Zentangle Inspired Art (ZIA) section of this chapter, we will begin to explore color as we keep our drawing tools in the achromatic scale but use colored papers on which to create our art pieces.

As we view an abstract drawing, the patterns and shapes leave an impression in our minds. Squares express symmetry, perfection, stability, organization, self-reliance, or confinement. Circles can represent independence, completion, and containment. Ovals relate to fruitfulness, creation, and abundance, while stars symbolize being the best, reaching upward or outward. Shapes are common, and many have a similar meaning to society. A drawing containing jagged or angular shapes all pointing at one another can suggest anger or turmoil. Soft, free-form curving patterns interacting together give the feeling of harmony and coexistence. Our reactions can change by how the shape interacts with the other shapes. Configurations of a pattern or shape also affect how the composition is interpreted.

Each viewer's emotional response will differ because it is also affected by the viewer's past experiences. This is one of the reasons tangled tiles make a great outlet for visual journaling. Visual journaling is expressing one's self through imagery rather than words. There are times in life when we have no words to deal with daily life, or the feelings inside are not ready to be categorized or have not yet surfaced. Visual journaling offers a more private release of thoughts.

Although the focal points are abstract, they still convey a message. The first tile's graphics (at left) are calming and peaceful. The second's (above) is edgy and creates feelings of caution, turmoil, or hazard.

ORGANIC LINEAR PATTERNS

MATERIALS

- 01 pigment ink drawing pen
- m pencil

patterns.

- sketchbook
- white tile
- parent sheet of Lokta paper

Use a white tile to create today's Zentangle tile using the three new patterns and any previously learned

DAILY TANGLES

Try these new tangles. Yincut can really come allive with sparkles and shading. For success with Locar, pencil in a string stem to build the spiny leaves on. Locar is the perfect introduction to Verdigogh. Verdigogh's needles are more free-form and cross in several directions. Practice these patterns in your sketchbook until they feel comfortable. Turn the sketchbook as you work to the correct angle for ease and accuracy.

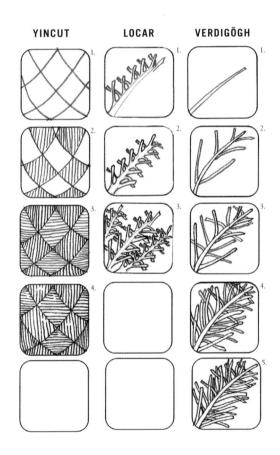

INTRODUCTION TO TANGLED JOURNALING

I come from a long line of journal-keeping women. Every year at Christmas my grandmother gave me a diary, trying to impart the tradition. I started out writing in the journals, but by the end of January I was only drawing in them. Though my journaling method was not popular with the elder women of the family then, little did they know decades later we would call it visual journaling, and it would be very popular. I especially love visual journaling with tangles on a tile or in a small sketchbook. I call it "tangled journaling." The quickness makes it doable even on hectic days. I also enjoy the discreetness visual journaling provides. One person's interpretation will be

very different from another's, and neither knows exactly what was going on in the artist's mind. Tangled journaling gives me time to organize my thoughts, feelings, and words. Put together your own a take-along Zentangle kit. You may want to purchase one, create your own, or repurpose something that you have. You may want to stay true to the original kit and bring just white tiles or add ATCs, black tiles, white pen, and pencil. Fold a sheet of paper into an accordion fold and create a reminder sheet of tangles to place in your kit. If you choose to tangle on the outside of the kit, use the appropriate pen for the surface of your kit.

Top: These two are samples of kits you can get from a Certified Zentangle Teacher. Bottom: This example is folded from a piece of Lokta paper. See the Appendix to learn how to fold your own ATC and Zentangle Tile Carrier.

ORGANIC PATTERNS

MATERIALS

- 01 pigment ink drawing pen
- m pencil
- white pencil of your choice
- sketchbook white tile
- ATC pack of midtoned colors

THE BEAUTY OF THE ORGANIC patterns is their ability to fit in so many odd shapes and combine easily with completely contrasting patterns.

DAILY TANGLES

Try these three patterns. Today's tangles all contain curved lines. The pattern Pepper is similar to the pattern Festune. Ynix can be used to move the eye. Slow down the pen as you draw the halo and keep the space an even width from the central shape. I think of Squid as Mysteria's cousin. It is similar, but Squid's center feels more grounded, and the tentacle area is airy. Pay attention to the placement of the tentacles in each step. Do not draw all the orbs identically or with drastic differences in size. A small variation holds interest and lets the components come together. Practice these patterns in your sketchbook until they feel familiar.

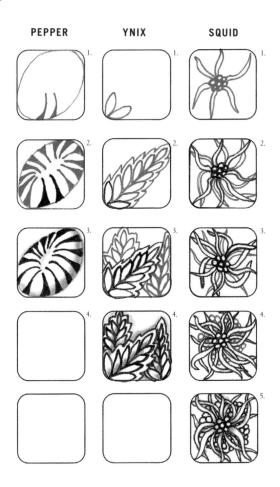

USING THE ACHROMATIC SCALE ON MIDTONED COLORED PAPER

I have always loved drawings using an achromatic value scale that have been created on colored paper. The color of the paper is the background to the art piece, so not all colors work well. You will find it is easiest to work on paper with a midtoned value, which is the focus of this exercise. This allows the graduating white of highlights as well as the graduating gray tones of the shadows to show equally. Gray, beige, and ochre papers all work for this. Blue tones will give the piece a feeling of coolness and still work for a large variety of gray tones to show. Yellow and pink are

a little trickier because, even as midtoned hues, they're brighter and can wash out highlights. When working on colored papers with a brighter background, harmony is harder to achieve. Examine the composition often by holding the piece at arm's length. Turn the tile and look at it from every angle for possibilities before choosing the next pattern.

Using the patterns of your choice, create an achromatic scaled tangle on a midtoned ATC. Try creating other ATCs using the same patterns on several colors.

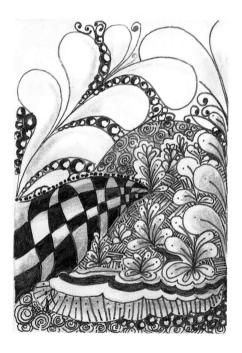

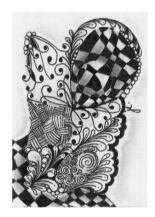

The first piece was created on a white tile that was partially covered with a layer of dried blue Gelatos. Contributing artist Judy Lehman drew the tangles in the achromatic scale on the pink ATC, center. On the green ATC, Judy used a light green pastel pencil for the highlight and a dark green for the shadow.

CURVY AND LINEAR ORGANIC PATTERNS COMBINED

MATERIALS

- 01 pigment ink drawing pen
- m pencil
- water-soluble graphite
- sketchbook
- white tile

ORGANIC PATTERNS INTERTWINE well together. They create edges full of nooks and crannies that are interesting transition points for changing patterns.

DAILY TANGLES

Try these three patterns. Today's patterns all have an organic feel to them but visually are very different. Vitruvius's square-in-a-circle pattern creates lively movement to the area it is used in. Courant has a maze-like appearance that works as a background or as the pattern on a focal shape. Sedgling is as fun to draw as it is to sav.

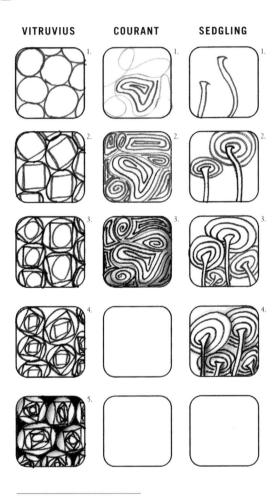

Practice the new patterns in your sketchbook until they feel familiar. Then create a Zentangle tile using today's patterns and any other patterns or Tangleations of patterns from this week.

ZENTANGLE INSPIRED ART: TANGLED JOURNALING

Tangled journaling is a great way to clear your mind, express your-self, or change your mood. There were two example tiles of this in the chapter intro. The simplest form of tangled journaling starts by drawing a string and going through the process of creating a Zentangle tile just as we do every day, with one exception. The tangled patterns I use are picked to represent how I am feeling. When I do tangled journaling, I use one of the lines on the back of the tile to write a reminder or a comment that will trigger my memory of that tangled journaling session.

I drew the pattern with a drawing pen and then used water-soluble graphite for the shading. There is more control in the gray tones because you can create a wash with the graphite and apply it with a brush. The tile uses a light wash that is applied and then allowed to dry between coats to build up the darker shadows.

CURVILINEAR GEOMETRIC PATTERNS

MATERIALS

- 01 pigment ink drawing pen
- m pencil
- sketchbook
- white tile
- take-along Zentangle Kit

Practice these patterns in your sketchbook until they feel familiar. Use the three new patterns in combination with any of our previously learned patterns or a Tangleation of them to complete your tile. Remember to use the eleven-step process for creating your Zentangle tile as you work.

DAILY TANGLES

Try these three patterns. The pattern Gneiss has a base that's convenient for building a new pattern in. Cadent has two variations—one creates a square pattern, the other a triangular pattern. Huggins is a great woven pattern that works up very fast once you catch on.

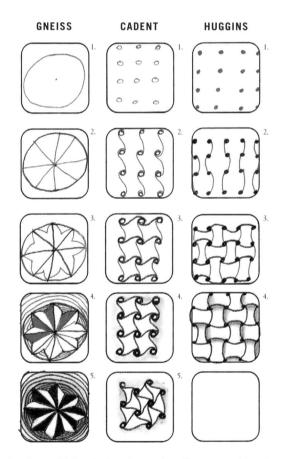

Today's patterns all fall under the category of curvilinear geometric patterns.

CURVILINEAR SHAPES ARE BASED

on a curved line and contain few, if any, straight lines. The latitude grid that runs on a map of the round Earth is an example of curvilinear barrel distortion. Inverting a line curve in is called curvilinear pincushion distortion. Tangle patterns that are based on a grid can take advantage of barrel and pincushion distortion to add form and volume.

Notice that barrel distortion gives the illusion of the grid coming forward, while pincushion distortion gives the illusion of the grid descending to the background.

TANGLED JOURNALING ON THE GO

I often use a simplified form of two-pointed curvilinear perspective in my tangled journaling. I start drawing the curving ground line or horizontal line in barrel or pincushion distortion. The focal shape is a line drawing, drawn with a pen. I continue to create the shapes I intend to place on or along the distorted horizon line. Next, I fill in the string areas with tangled patterns to add form, shape, and interest. I shade the drawing so the piece has dimension. On the back. I write the location and date when I sign it.

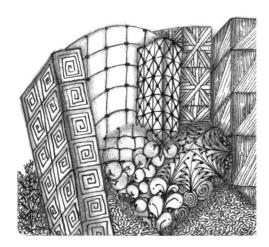

This barrel perspective was perfect to use when drawing the hilly streets of San Francisco that surround Union Park.

GRAB YOUR ZENTANGLE take-along kit. Go in search of inspiration. Find an area of interest to draw in. It can be as close as another room in your home, your backvard, the library, or a coffee shop. Find a place you will not be bothered, take out your kit, and get comfortable. Create on a white tile a two-point curvilinear perspective ZIA of your choice.

GEOMETRIC RECTILINEAR PATTERNS

MATERIALS

- 01 pigment ink drawing pen
- pencil
- sketchbook
- white tile

RECTILINEAR SHAPES ARE sharp and angular. They often reflect man-made or engineered objects or the rigid and geometric forms in nature. Art deco style incorporates many rectilinear designs and shapes. Today's tangles are all rectilinear in design.

DAILY TANGLES

Try these three patterns. Rain reminds me of the geometric lines found in nature, whereas Cubine and Beeline resemble man-made objects. Practice these tangles in your sketchbook until they feel familiar.

DEWDROPS

A dewdrop is another Tanglenhancer and one of my favorites for using both the barrel distortion of the curvilinear patterns and the structured characteristics of rectilinear patterns. Because the dewdrop is a magnified circular section of the tangle surrounding it, the pattern inside the dewdrop is enlarged. This gives the illusion of the pattern being magnified. Careful attention to the shading creates the illusion that there is a drop of liquid or a transparent orb causing the magnification. Use dewdrops to break up a monotonous pattern, add a touch of detail, attract the eye, invite the viewer to look closer, or create whimsy.

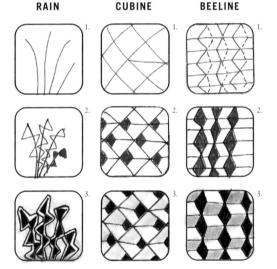

The dewdrop requires a little more practice than the other Tanglenhancers we have learned. Turn to a clean page in your sketchbook. Create a few 2½-inch (6.4 cm) borders on the page. Use any of the geometric patterns we have learned to create a different dewdrop in each of the borders. This is a very useful Tanglenhancer; try to incorporate a few on the tiles you create in this chapter.

ZENTANGLE TILES WERE created so that when a group of completed tiles are placed together they create a mosaic. Lay out your tiles with edges touching, without gaps between the tiles. This mosaic represents your Zentangle journev. As you look over your mosaic, see how far you have come. Somewhere in the middle of those tiles you will see your style coming out. Take time to enjoy your creations and reflect on your work.

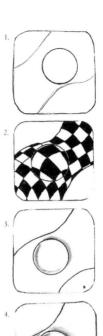

Step 1: Draw a circle in the area in which you want to place a dewdrop. Step 2: Fill the area with a tangle, making it larger inside the dewdrop area. (To demonstrate the shading of a dewdrop, I have removed the tangle from step 3.) Step 3: The area of the dewdrop that falls where the light source creates a highlight has the shading on the outside of the circular border. The shading is blended away from the circle. The area of the dewdrop in the shadows has the shading on the inside of the dewdrop's circular border. The shading here is blended into the center area of the circle. Remember to leave the highlight in a circular shape. Step 4: Add the cast shadow the dewdrop would create, opposite the highlight.

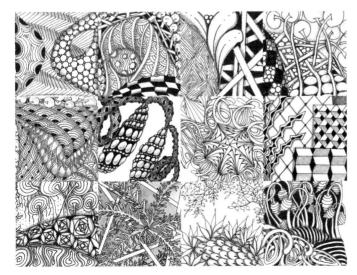

A Zentangled tile mosaic

ANOTHER LOOK AT CURVY AND LINEAR ORGANIC PATTERNS COMBINED

MATERIALS

- 01 pigment ink drawing pen
- white pencil
- graphite pencil
- colored pencils
- sketchbook

- white tile
- one sheet each of 8½" x 11" (21.6 x 28 cm) paper in red, yellow, blue, green, orange, and purple

TANGLE PATTERNS ARE key examples of how artists break the shapes they want to draw into the parts they are composed of, which we often refer to as a stroke, and then re-create them

DAILY TANGLES

Try these three patterns. Jetties begins by filling the area with circles. Varying the last step's placement creates interest for the eye. This step also gives the circles their dimension. The last two patterns are built upon a grid. Sampson starts on an x grid while 'Nzeppel is based on a diamond-shaped grid that is further divided. The rounded-edge shapes added in the last step give it its organic look.

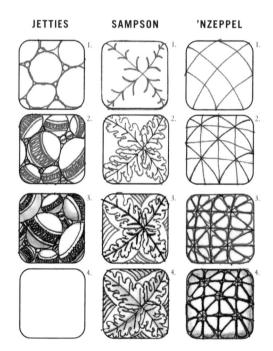

CREATING ZIAS ON BOLD COLORS

Today we are going to explore working on boldcolored paper with an achromatic color scale and using colored pencils for highlights and shadows. The highlight requires a pencil in a high-key shade of the paper, while the shadows require a pencil in the low-key shade of the paper. On bold hues, graduated shading in the highlights is important for the composition's balance and harmony. When you are working with bold-colored papers, you will find they affect the tones of the patterns just as when we went from white to black paper. Yellow can cause problems because it does not let the highlights stand out. Green and red make it more difficult to achieve harmony between the tonal values of your drawing and the tonal value of the paper. Working on dark blue is similar to working

on black tiles and may require a white pen or a pen with a high-key colored ink in the hue of the paper. Start by going through your previously created Zentangle tiles. Look for tiles that contrast with one another. Choose a tile with open, airy graphics and one with busy graphics. Choose a tile that has the majority of the tone values in the high-key area and one with a majority of dark tone values. Photocopy the tiles on a piece of red, yellow, blue, green, orange, and purple paper. Cut out the tiles and use your white and graphite pencil to give the tiles highlights and shadows and then use colored pencils on another copy. As you experiment with creating ZIA on the colored tiles, keep notes on what you learn in your sketchbook for later use.

Creating the highlights and shadows requires a heavier application of both the white and graphite pencils. Blending out the edges of the highlights often dulls the brightness of the highlight. After blending, touch up the center of the highlight using the white pencil.

REPETITION CREATING TRANSFORMATION

MATERIALS

- 01 pigment ink drawing pen in black and sepia colors
- pencil and/or sepia-colored pencil
- sketchbook
- two white tiles
- small brush
- water

Practice these patterns in your sketchbook until they feel familiar. When you are ready, create a tangled tile using Paradox and B'Tweed. Use any other patterns you wish to finish the tile.

Some patterns create one look when used singly but transform their look when used in a grid or in multiples. Rick's Paradox and B'Tweed are examples of patterns with many looks. B'Tweed is an organic pattern that can easily bring interest to a small area or harmony to an area with contrasting patterns. When used in a circular area that is divided into pie shapes, the design becomes a star-centered organic shape. When an area is divided into equal widths and filled with B'Tweed, the pattern looks more woven and man-made.

DAILY TANGLES

Try these two patterns. Keep the lines spaced evenly when drawing Rick's Paradox and always turn the tile between strokes, in the same direction, when drawing this pattern. When drawing the pattern B'Tweed, if you start the first stroke from the left bottom corner it will work in harmony when used to fill a grid or repeated to fill an area.

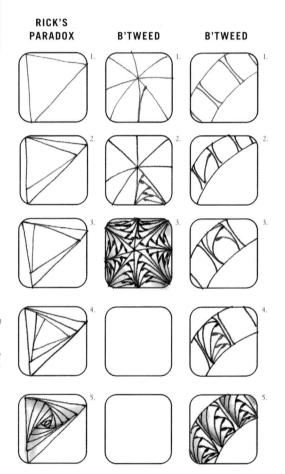

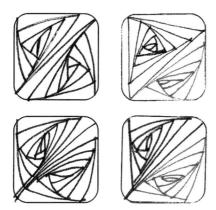

Both of these examples were created using a square divided into triangles and filled with the pattern Rick's Paradox. The difference is achieved by altering where the pattern starts on the side where the triangles are touching when you begin the second triangle. The first alters them; the second mimics the first stroke of the pattern in the first triangle.

ZIAS CREATED FROM SEPIA INK

We cannot wrap up a chapter on organic shapes without using sepia ink to create a ZIA. Sepia ink has a beautiful, rich, warm earth-toned brown with a red undertone. The hue naturally works well with organic shapes. Use a Sepia 01 pen to draw the tangles. To create shadows, use a sepia-colored charcoal pencil, colored pencil, or wash created from the ink in the sepia brush pen. If you use a water-soluble pencil, use a small brush and water to graduate the tones in the shadows on your patterns.

Once you feel comfortable with the pen, create a ZIA on a white tile. Incorporate the organic patterns or a Tangleation of those patterns to complete your art piece.

Contributing artist Angie Vangalis drew the tangles using a sepia 01 pen and then created a wash from the ink in the sepia brush pen for the shading. The wash was applied with a brush. The rich-toned sepia ink, combined with the organic patterns used on this tile, are warm and inviting.

UNDERSTANDING AND USING COLOR

IN THIS CHAPTER, THE DAILY ZENTANGLE TILE will still be done in the traditional achromatic scale, but the exciting news is that the ZIA section of each exercise will include adding color to your tiles. To work successfully in color, we have to understand it. Each color or hue has a temperature, either warm or cool in nature. The warm colors get their warmth from the amount of yellow in them; the cool colors are cooler because they have blue in them. A warm red mixed with a warm blue will make a very different purple than one created from a cool red mixed with a cool blue or a warm red mixed with a cool blue.

The top color wheel is created from the warm primary colors of cadmium red medium, ultramarine blue, and cadmium yellow medium. The bottom one is created from cool primary colors of quinacridone red, cerulean blue, and azo yellow.

A color wheel is made from the three primary colors: red, blue, and yellow. Mixing two of the primary colors creates a secondary color. Secondary colors are orange, green, and purple. Last, there are six tertiary colors made by mixing a secondary color with a primary color. They are yellow-orange, red-orange, red-purple, blue-purple, blue-green, and yellow-green. In the beginning, if you stick to mixing warm colors with warm colors and cool colors with cool colors, you will have the easiest success and avoid frustration. It does not matter whether the medium you use is watercolor, gouache, colored pencil, ink, or water-soluble crayons, the colors will react the same.

Secondary colors mixed from a warm color and a cool color appear duller. These mixes are great for use in the shadow areas.

A color wheel is a tool that helps us choose the colors for our palette that work well together. Our palette is the selection of colors we will use to paint or draw with. Palette choice is important because color helps the artist express emotion, interest, and depth.

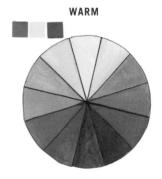

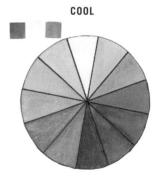

The warm colors remind me more of the colors in nature. They appear larger in size than they are and seem to come forward. The cooler shades remind me of the colors of the tropics. They feel lighter, and items painted with these colors seem farther away.

WATERCOLOR

MATERIALS

- 01 pigment ink drawing pen
- 2B pencil
- sketchbook
- white tile
- watercolors
- small round paintbrush
- water

DAILY TANGLES

Try these two patterns. Up until today, all the tangles have been official Zentangles. This week, each day we will learn one official Zentangle and one tangle or Tangleation created by one of the artists from the book. Today's official Zentangle is Tagh. At times when I draw this pattern into an area it reminds me of seedpods, other times pinfeathers, and yet others architectural molding. It is a pattern of many faces. Tat is a pattern I named and have drawn on everything since I was a kid. It is a one-stroke pattern that changes directions. As you practice Tat, go slowly the first few times through the pattern to help keep the proportions correct. Tat reminds me of the patterns my grandmother used when she taught me tatting.

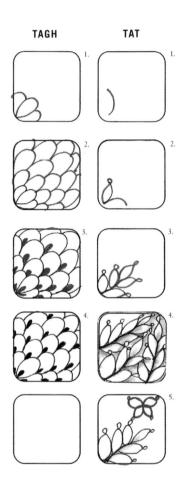

Practice these patterns in your sketchbook until they are familiar. Using today's patterns and any other pattern or Tangleation of previously learned patterns, create a Zentangle tile. Remember to practice the eleven-step process as you create your tile. Periodically stop to look at the tile from a short distance. Turn the tile as you examine the possibilities from every direction.

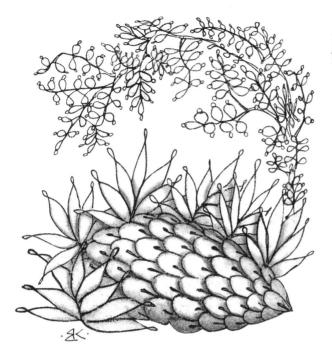

Tat was used in a rounded form in the pattern at the top of the tile and in a spiky form in the lower side of the tile.

YOUR WATERCOLOR PALETTE

Almost every boxed set, whether it is pencils or paint, comes with both a warm and cool selection of each of the primary colors. For example, the colors in most travel watercolor sets can be divided into a cool and warm color wheel. For the primary warm color wheel. I used cadmium red, aureolin yellow, and ultramarine blue. For the cool color wheel, I used guinacridone rose, lemon yellow, and cerulean blue.

On a page in your sketchbook, create warm and cool color wheels using watercolor, gouache, or colored pencils. Experiment creating color mixes with the leftover colors from your mixes. Label them so that you can reproduce the colors.

I chose cadmium red over vermilion because the amount of red to yellow was more balanced in cadmium red. I chose quinacridone red over alizarin red because there was a greater balance of red to blue in the quinacridone red.

PAPER BATIK

MATERIALS

- 01 pigment ink drawing pen
- white Glaze gel pen
- 2B pencil
- sketchbook
- white tile
- tile from watercolor paper
- watercolors
- small round paintbrush
- water

DAILY TANGLES

Try these two patterns. Today's official Zentangle is Kathy's Dilemma. This fun tangle fills any shaped area of the string with triangles. I love how this pattern lends itself to altering. If the triangles are drawn large enough, a pattern can be drawn in them. If the background is spacious, a pattern can be added there, and so on. As much as Flux shows up in my work. I am sure you can tell it is one of my favorite patterns. Flux is also one of my favorite patterns from which to create Tangleations. Flux in vine form can be used as a great border, a broken line pattern that stops and starts through other patterns, entwined around itself to fill a whole area of a string, or used to transition between two patterns.

Practice these patterns in your sketchbook until they feel familiar. Create your daily Zentangle tile using today's patterns and any previously learned patterns but add a twist: Try to create a Tangleation of your favorite pattern to add to this tile.

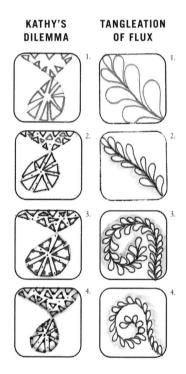

THE GEL PEN gives us a lot of options for use in art. Today we are using it on white paper. Batik work will often have a repeating pattern throughout the piece. For this exercise, it is fine to stick to using one or two repeating patterns or several different patterns. Work in good lighting on this project. When you use the pen on white paper, the ink will appear on the paper as a milky light blue color. When it dries it will be clear. Remember this ink takes a couple of minutes to dry.

We will not draw a string with a pencil for this piece because the pencil will show through the ink and watercolor. Draw a thumbnail sketch of one in your sketchbook to follow or just pick up the Glaze gel pen and start drawing in one area of the tile. When there seems to be enough of that pattern, stop, cap your pen, and while the ink dries, examine your tile from arm's length. Turn the tile in all four directions, examining the possibilities your art piece can go. When you are ready. draw in the next pattern. Continue until you are satisfied with the tile. Let the ink dry.

Decide on a color palette for painting the background of the tile. The paint is going to make your drawing pop out. When mixing the watercolor paint, make strong washes of color. The bolder the background color, the more the white line drawing will pop. Once your palette colors are mixed, you are ready to paint. Mist the tile with water to work with a wet-on-wet technique. In this technique, the paper is wet and the medium being used on the paper is wet. This technique is great for getting wonderful natural color mixes. Make sure your colors will mix to create a palette you are looking for. Alternatively, you can also just paint the color directly on the dry tile.

This tile is created using one pattern, Dyon, and a cool color palette. The paper was wet before the paint was applied. Contrasting colors were used to create the shadows.

This tile uses many patterns, which can get busy. To counter the busyness, all the patterns were contained in circular shapes. It was also painted using a wet-onwet technique, but this one was created from a warm color palette.

INK AND WATERCOLOR

MATERIALS

- 01 pigment ink drawing pen
- 03 permanent ink drawing pen
- 2B pencil
- sketchbook
- white tile
- tile from watercolor paper
- watercolors
- small round paintbrush
- water

DAILY TANGLES

Try these two patterns. Today's official tangle is Striping, which is a great pattern that can be used to add drama, grab the viewer's attention, or transition between patterns that are opposite on the value scale. You can easily change the tonal value of this pattern by changing the size of the white stripe, black stripe, the ratio, or both. The other is an official pattern called Zinger. I learned this tangle from Maria Thomas during my Zentangle certification class.

Practice these patterns in your sketchbook until they feel familiar. Create a Zentangle tile using today's patterns and any pattern or Tangleations of previously learned patterns.

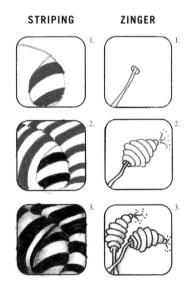

COMBINING INK AND WATERCOLOR

Today's ZIA is going to combine ink and water-color, which make an elegant combination. One of my favorite styles of this combination is botanical drawing. Create a tangled tile in the normal fashion from string to shading using organic patterns and the permanent ink drawing pen. I have found if you have to go back into a piece with the pen after painting, these pens work better on top of watercolor and most paints. When you are done, choose a color palette from the warm or cool color wheel and add color to the tile. Darken the color in the shadow areas and lighten or leave white areas for highlights in the high-key areas.

I used the warm color wheel to choose the colors for this tile. Next I decided on a complementary color palette of blue-green and red-orange. I toned down each color with a small amount of its complementary color to create earthy colors for this piece. I chose to preserve most of the white background and to create a light and airy piece. To balance the negative and positive spaces of the piece, I then used layers of light washes of the toned-down colors to paint some of the tangles. Let the washes dry between coats.

On this piece, I used the same color palette but chose the colors from the cool color wheel. Adding a small amount of the complementary color to the color I wanted to darken created the darker colors. This was also painted using glazes that were mixed much darker than those for the previous tile.

INK AND GOUACHE

MATERIALS

- 01 pigment ink drawing pen
- 03 permanent ink drawing pen
- 2B pencil
- sketchbook
- white tile
- tile from watercolor paper
- watercolors
- gouache
- small round paintbrush
- water
- low-tack tape

DAILY TANGLES

Perfs are the last of the official Zentangle Tanglenhancers. The official definition is "adding pearl-like dots that surround your tangle. This was a popular technique used on manuscripts during the medieval times. Perfs were used often around large letters to add drama and focus." When used to surround a tangle, they can have the same effect. When coloring in perfs to create colored orbs, do not forget to leave a white highlight if the orb is large enough. They combine well with auras and rounding, which are also Tanglenhancers. Perfs are very effective if you take your time and focus on deliberate pen strokes. If you are hurried and messy, they can have quite the opposite effect. Taghpodz has a middle tonal range, so it works well for shifting between heavy and lighter tonal patterns. The vertical lines can change to diagonal, horizontal, or crosshatched.

Create today's Zentangle tile using perfs on the patterns of your choice. Take your time to draw the perfs. Keep their size and shape uniform. Try them in both black and white and with a Tangleation of your own.

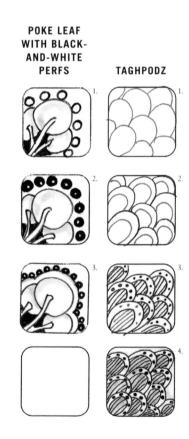

GOUACHE

Gouache is a paint that is colored, pearlescent, or metallic. Depending on the manufacturer and color, the paint can range from semiopaque to opaque. Used like watercolor, this medium adds a little more weight and texture than watercolor.

Contributing artist Angie Vangalis started this ZIA exercise by using watercolor or gouache on a piece of hot-pressed watercolor paper. Use low-tack tape to tape down the edges of your paper to prevent it from warping. Choose a watercolor or gouache palette. Instead of drawing your string, you are going to lay down the string using areas of color. Rinse your brush completely clean between colors. Let the paint dry completely before continuing. Remove the tape and use a pigment ink drawing pen to draw the tangles onto each of the sections of watercolor. To add shading, use the pen and apply stippling. Stippling is created by adding small dots at various distances apart, depending on the amount of darkness desired. A lot of dots close together will create a dark area; a few with a slight space between each will fool the eye into thinking there is shading in that area. Last, add gouache for highlights.

This piece contains gouache and ink alone. Angie began this piece with a pencil string and penciled in some of the basic elements of each tangle. The gouache was applied using a midtoned yellow-gold and allowed to dry. The darker value gold was added later. Once the gouache was completely dry, a permanent ink pen, size 05, was used to define the patterns and rounding was used to darken the crevices.

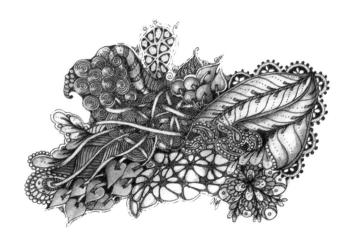

The colors, black ink shadows, and gouache highlights all work well in the piece to keep the eye moving and the viewer's interest piqued.

MARKERS AND COLORED PENCILS

MATERIALS

- 01 pigment ink drawing pen
- 2B pencil
- sketchbook
- white tile
- tile from watercolor paper
- colored pencils
- alcohol-based ink markers

DAILY TANGLES

Try these two patterns. Today's official pattern began as a Tangleation of Poke Root. Poke Leaf works great as a filler and will come easy because it only requires changing the last step of the pattern Poke Root. I created the pattern Growth while I was on vacation in San Francisco. It is patterned after a design of a stylized tree carved in the tiles of the entry to a restaurant in Chinatown. I have spread the pattern apart in the first four tiles, but it should be drawn closer together as seen in the last tile.

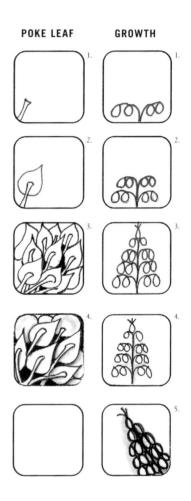

Practice these patterns in your sketchbook until they feel familiar. Create your daily Zentangle tile using these patterns and Tangleations that you have created or learned.

ALCOHOL-BASED INK MARKERS AND COLORED PENCILS

Alcohol-based ink markers contain transparent ink and dry quickly. Test to see whether these markers bleed on the paper you will be using for this exercise. If they do, select a colored pencil the same color as the marker. With the colored pencil, outline the area before filling in with the marker.

Today's technique uses these markers to lay down color washes. Use the marker's brush tip to color areas of the tangled string, preserving any highlights you want to keep by leaving the marker out of those areas. Work quickly and only let the tip of the marker come into contact with wet ink. Going over an already dry area will create a dark spot in that area. Because the ink is transparent. the first layer shows through the second layer. making it darker. After the first wash is down, use the same marker to color over any areas that

would be darker because they are in the shadow area. Use a blending pen to create or enhance highlight areas.

Use colored pencil to add highlights and shadows. Colored pencils are opaque and leave a soft line behind with a look similar to pastels. Combining media, such as markers and colored pencils, gives a rich range in color and textural differences to your artwork.

If you choose to start with a string, pencil it in very lightly. Continue with our botanical theme and draw organic patterns using the pigment ink drawing pen. Do not add shading yet. Decide on a color palette. Apply single-layer washes of color on the pattern areas of choice. Build up the color in the shadow area by applying another layer using the same marker. Last, apply the shadows and highlights using the colored pencils.

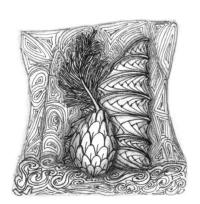

To bring the seedpod's fronds forward, I traced over them a second time, making them darker than the background. An object that is darker will appear closer to the viewer. Color can also help separate busy patterns.

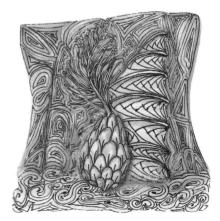

This tile was drawn with the pigment ink drawing pen, and then colored in using a palette of blue, yellow, and green.

WATER-SOLUBLE INK PENCILS

MATERIALS

- 01 pigment ink drawing pen
- 03 permanent ink drawing pen
- 2B pencil
- sketchbook
- white tile
- tile from watercolor paper
- Inktense colored pencils

DAILY TANGLES

Try these three patterns. We are using two official patterns, Meer and Enyshou, today. Contributing artist Judy Lehman chose to work with the two patterns because she finds them very adaptable. Be aware of keeping the spacing even between the diagonal lines as you draw Meer.

Enyshou is a great pattern for moving the eye along, transferring between patterns, or adding an element of surprise. Reef, a pattern that Judy created, can be used when you want vertical lift in your design. Reef is easily adapted to be either organic or geometric by nature. Judy uses an art technique, one-point perspective, to emphasize the structure's perspective creating depth with the pattern.

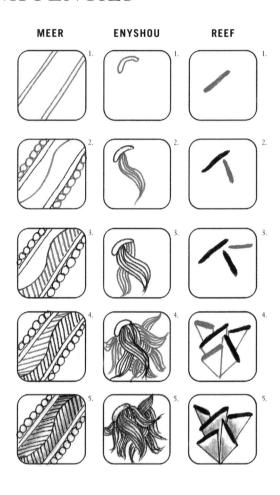

Look at the forth step-out of Reef to see the exact point to where all slanted lines are drawn. The vanishing lines may be penciled in using a straight edge or freehanded, pivoting from the point to the top edges of each reef.

CREATING ZIA WITH INKTENSE COLORED PENCILS

Inktense colored pencils are water-soluble colored pencils that have a core of colored ink. Similar to colored pencils, these pencils are bold and vibrant in color when used both dry and wet. When used dry, they blend well together when you place one color over another. They can be colored onto a piece of paper and then lifted and blended with a wet brush. They can be dipped in water

and used to apply the ink directly to the paper or shaved and blended with water on a palette to create a wash.

Start your ZIA tile by drawing a light string and then use one of the drawing pens to draw in the tangles. Pick a color scheme and create a palette using the Inktense pencils. Color in the tile. Add shading by using complementary colors.

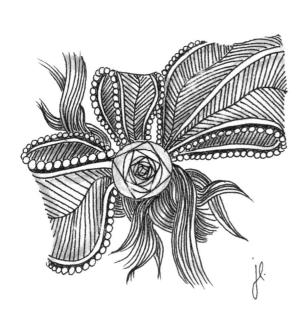

Judy, a fiber and textile artist, saw a ribbon when she looked at her string. By manipulating the size of the center diagonal lines of Meer, she was able to create perspective and depth. After the straight border and centerlines were drawn, she drew in the orbs. Notice the perspective achieved on the corners by drawing some of the orbs half-hidden behind the previous orb. Enyshou has been removed from its cylindrical state and drawn in a line that gets smaller as it descends into the background.

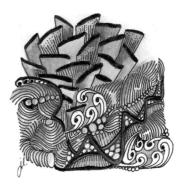

Judy started this tile by drawing her pattern Reef on the tile. A Tangleation of Msst was used as a shading pattern on Reef. By turning the Tangleation, Judy kept the lines where the shading would be darker, and where it becomes lighter, the dot pattern was used. She decided next to draw in the pattern Isochor to create movement and to add contrast to the angular openness of Reef. After that, the other patterns fell into place. When she was finished drawing the tile, she realized the Reef pattern's black tops were quite strong and were overtaking the other patterns, so she decided to use a primary palette of yellow, red, and blue. The yellow atmosphere around Reef tricks the eye into thinking that there is less contrast between this pattern and the others.

COLORED TANGLED JOURNALING

MATERIALS

- 01 pigment ink drawing pen
- Fine tip 03 permanent ink drawing pen
- 2B pencil
- sketchbook
- white tile
- white tiles, white ATCs. or 31/2" x 21/2" (8.9 x 6.4 cm) tiles from watercolor paper
- Gelato opaque paint sticks, or Caran d'Ache crayons, or watersoluble oil pastels
- small round brush
- water

DAILY TANGLES

Sez is an official tangle. The pattern offers the artist many looks by altering size, shape, and density. Eke is also a great pattern for creating Tangleations from, and today's second diagram of Eke shows you some of my favorites. Remember to stay focused while creating these patterns. I find it is easy to fall into the bad habit of going too fast, especially when drawing the one-stroke patterns such as Eke. Both of these patterns come out best by focusing on the spacing.

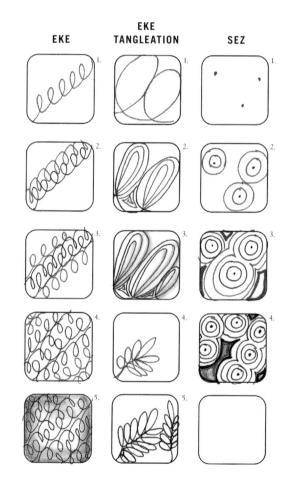

Tangleations of patterns give tanglers the option to alter patterns so they fit the theme or message of the artist.

WATER-SOLUBLE CRAYONS

Water-soluble crayons come in wax form, paint, or oil pastel. They can be used dry or wet. They can be applied directly dry and burnished to blend colors together. When using them dry, they can be applied directly to the paper and then blended with water, gel medium, or gesso. They can also be applied to a palette, mixed there, and then applied to the paper with a brush. Each has a unique look and a different texture covered in the Basics section (chapter 1). As a mixed-media artist, I have found endless applications for all three of these items in a lot of my art.

This ZIA exercise is going to start by skipping the border on the tile or ATC. Begin by drawing a string. Choose a type of water-soluble crayon and add tangles. Use the water-soluble crayons or a permanent ink pen to add detail to the tangles. Create shading using the complementary colors of the crayons you started with.

From my drawing table in my studio, I saw a dark greenish funnel cloud in the sky spinning over the city. I grabbed my Gelatos and applied the colors of the funnel cloud and background clouds. I blended the colors directly on the ATC with my finger. I drew the city peeking below the clouds, and using a Tangleation of Sez, I filled in the clouds. I then used oil pastel to draw Eke into the funnel cloud. A brush and water picked up some of the blue water-soluble oil pastel for shadows. Caran d'Ache applied the highlights and a few directional lines because of the textural effect they add. Do not be afraid of mixing media to achieve desired results.

This piece had a string penciled in and was drawn using a 01 pigment ink drawing pen. Gelatos mixed with gesso create the sky. The organic patterns were painted with Gelatos mixed with gel medium, and the highlights were added using gesso. The color palette is calm and cheerful.

DEFINING AND USING STYLE

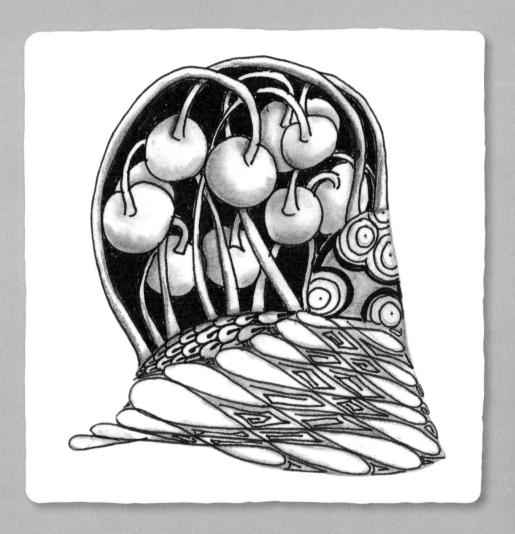

WHEN IT COMES TO STYLE IN ART, the word has two main meanings. The first refers to the trends of an era or art movement. The Zendala section of this chapter will address this meaning of style as we explore meditative drawing with round tiles. The second definition means a distinct characteristic or trait of an artist's work, giving a unity to the artist's body of work.

This chapter concentrates on how to recognize and grow your personal drawing style. We will look at options of expression from flair, neat lines, and borders to transforming and creating tangles. We all have our own style. Personal style is made up of past surroundings and experiences, combined with what we like and are drawn to. We will explore ways to continue to express personal style, to keep our artwork fresh, and to continue to grow, starting with creating your own tangles.

As you look over your work from the previous twenty-eight days, you will see certain consistencies throughout the collection. In my case, it is how I use the patterns to play with the tonal values, juxtaposing light and dark tones with the use of a range of midtone patterns that interplay between the two.

Create another mosaic using the twenty-eight Zentangle tiles you have already made. Which characteristics do you see that appear the most often? What do you like the best about the collection? Take time to look and examine the mosaic for your style. Where would you like to see growth? Maybe it is in a tile that has more movement than the others or a tile that is airier than the others. This critique time gives an artist valuable information. It chronicles where our growth has come from and helps to direct our focus so our art continues to grow in the direction we want. In this chapter, some of the new patterns will be taught with a description and example versus the step-outs used in the past four chapters. The aim of this direction is to train your eye to recognize patterns and how they can be broken down into simple strokes.

As peaceful to look at as they are to draw, feathers are my go-to meditation when I need to calm down or center myself.

TRANSFORMING A PATTERN TO FIT YOUR STYLE

MATERIALS

- 01 pigment ink drawing pen
- m pencil
- blending stump
- sketchbook
- white tile
- black tile
- opaque gel pens
- colored pencils in coordinating colors to use for shadows and highlights

DURING MY ZENTANGLE certification course, we worked with the pattern Verdigogh. While on a break, I commented that in many of Maria's samples the feathers that she had drawn contained similarities to Verdigogh. Maria said that she likes to draw patterns in which the object is to follow the line as close as you can to the previous line without touching.

That is the basic step to turning Verdigogh into a drawing of a feather. Add the length to the strokes drawn, alter the shape slightly, and you have a feather. When we started, I said that you have to learn the steps of creating a Zentangle tile to achieve all the benefits of completing a Zentangle tile. You have to know the rules before you start breaking the rules. Now that you know how to use the steps of creating a tangled tile, you can alter the process without losing the benefits. In this project, the Zentangle tile breaks the rules but keeps the process. The focus required while

> drawing the lines close together when creating the barbs on a feather makes this a very meditative exercise.

The great thing about drawing a feather is that no two ever come out the same.

VERDIGÕGH IS THE

PATTERN that creates the evergreen boughs in the background, left. Notice the pine needles have a long rectangular shape. The barbs—tiny, hair-like parts of the feather—are shaped like sewing needles: fine and thin, with a point at the top. The barbs are drawn closer together than the needles on the tree. Feathers have a slightly different shape than an evergreen bough.

Practice drawing a feather in your sketchbook. The center shaft down a feather is called a rachis. You may want to draw the rachis as your string. Draw around the rachis the outside shape of the feather you want to draw. Some feathers have these wild, curly "after feathers" at the bottom. Add them last. Follow the steps of Verdigogh but use a sewing-needle shape to create barbs. Keep the barbs close together and stay within the string shape. When you have the concept down, begin on a white tile.

STYLE AND THE BLACK TILE

One medium that works very well on the black tiles is a gel pen. My three favorites based on opaqueness for use on the black tiles are Soufflé, which is matte ink, Moonlight, an opaque luminous gel ink, and Moonlight Dusk, a luminous gel ink. The dusk colors have the smaller nibs, but all three require drawing a bit larger than with the pigment ink drawing pens. Coordinating colored pencils can be used for shadows and highlights.

CREATING YOUR OWN TANGLE PATTERNS

MATERIALS

- 01 pigment ink drawing pen
- m pencil
- blending stump
- sketchbook
- white tile

ONE WAY TO ENSURE THAT YOUR Zentangle tiles stay fresh is to keep your strings fresh. It is easy to rely on old designs that have served us well before, but there is no growth in that. This week you have been examining your style. Do you use the same patterns for strings, or is there diversity in your string designs? If you already have a lot of diversity, maybe the answer is to try working without a string every third or fourth day. Keeping your artwork fresh means keeping the foundation of that work fresh.

For a warm-up exercise, turn to a clean page in your sketchbook and rethink the string. Come up with several new, unusual patterns to take your tiles to a fresh place. Once you have some that you are happy with, choose one for today's Zentangle tile. Create your tile using this string and any patterns or Tangleations you choose to use.

Who says we draw abstract worlds? These are moss balls that fall out of oak trees during windstorms. They remind me of Squid and Mysteria or a tree from Dr. Seuss. This is a double hit in the inspiration department because the twig of the oak tree has a wonderful scalv pattern to it. I decided to diagram both.

The moss balls are made out of a lot of little plants that are similar to those pictured in diagram 1. Notice those little drawings in diagram 1 are all one-stroke patterns. I put the two together and added a few more for a base, as in diagram 2. After I figured out the forefront, I drew a barrel-distorted horizon line behind the forefront of moss. Diagram 3 shows the barrel horizon line that can also be found in diagram 2, which is completely filled in. I then added the scaly twig the moss grew on. Diagram A shows the large scaly pattern of the bark. Diagram B shows the repeat of A and with the smaller scaly pattern of the bark. I will call the moss pattern Seuss and the bark pattern Scalv.

molding on the wall of the post office, a pattern in the dirt caused by runoff, or the sites found on a special vacation. The philosophy behind Zentangle encourages us to be aware of our environment by becoming more aware of the patterns around us. Creating Zentangles makes us more aware of the beauty around us. Suddenly the leaf on the ground is not just a green leaf, but upon

closer look we see a beautiful pattern created by

the veins running through the leaf. For starters,

discover the patterns around your home. Take a

AS WE HAVE DISCUSSED BEFORE.

tangles come from things we see. It may be a

walk with your sketchbook and a pen. Look for patterns that can be created in one to four stokes. It could be a pattern on a plant leaf, molding on a piece of furniture, a rock pattern in the garden. or the trim on a tea towel. Once you have found your inspiration, break it down into a few simple strokes in your sketchbooks. It might take a few tries to tweak it, so do not get discouraged.

Carry your sketchbook as you are out and about so you can capture the patterns you run into. Begin to incorporate your patterns in your daily Zentangle tile and ZIA.

GIVING FLAIR TO PATTERNS

MATERIALS

- 01 pigment ink drawing pen
- pencil
- two white tiles
- black tile or black paper
- vellum (optional)
- gold gel pen
- gold gouache

FLAIR IS THAT EXTRA-SPECIAL attention to detail. It is flair that adds the pizzazz to our art. Flair is the jewelry we give to our patterns and tiles.

In this tile example of flair, one of the patterns contributing artist Angie Vangalis calls Paizel is her version of the original Zentangle Opus. It reminds Angie of a paisley-patterned dress she was so fond of in the second grade. Paizel is particularly useful as a border pattern and uses the contrast of shapes to create interest. Each Paizel shape is separated by a series of hatch marks, which are also reminiscent of the official Zentangle Nekton.

Angie adds "nervous" broken lines with spirals and dots to finish off her Zentangles. "It's a lot like dotting an i or crossing a t or

> adding a period at the end of a sentence for me; it's the icing on the cake," she says.

For today's meditative Zentangle tile, incorporate Paizel and some flair of your own to your tile. Flair is another tool that gives an artist personal expression. Be fearless with your strokes and express your style today.

"Always start the Flux pattern from the edge and alternate the Paizel shapes in a yin-yang fashion; you will create harmony and interest," says Angie.

ZIA: ILLUMINATED LETTERS WITH TANGLES

Angie calls these *Illumitangles* because they are, in essence, modern-day illuminations. Illuminated manuscripts from the Middle Ages have always fascinated Angie and are the inspiration for these tangles. An illumination is when gold or silver metal leaf is incorporated onto the page of a manuscript. So, for this ZIA, I printed out the outlines of the letters M and B, using my laser printer and Pacon Multi-Media paper (for the white background) and Daler-Rowney Canford paper (for the black background).

The gold used on the letter *B* is done with Finetec gold gouache. This gives a different appearance while entertaining the essence of gold-leaf metal. Applying gold leaf to a surface is a technique called gilding. Traditional gilding requires the application of several layers of a specific type of gesso and bole and a lot of patience.

Angie uses a layer of acrylic matte medium to build up the letter. Once it's dried completely, she gives the acrylic a "huff" of air (as if you were cleaning eyeglasses). The gold leaf metal is carefully applied to the acrylic. A piece of glassine is placed over the letter and burnished with an agate gold leaf burnisher and then the excess is brushed away, leaving a smooth, raised, gold letter. The first step is to lay out the string. The gilding must be done in the second step of this type of illumination; otherwise, the genuine or imitation gold leaf will adhere to other areas of the artwork.

Try your hand at illumination on today's ZIA. Use a tile or a sheet of art paper of your choice, in the size you would like to work.

The gold used behind the letter M is done with a gold gel pen.

NEAT LINES, BROKEN BOUNDARIES, BORDERS, AND FRAMES

MATERIALS

- 01 pigment ink drawing pen
- m pencil
- blending stump
- pre-strung tiles
- white tile or Artistico paper cut to desired size
- white ATC

NEAT LINES, BROKEN BOUNDARIES, borders, and frames are tools an artist uses to add flair, sparkle, or weight.

Neat lines tend to tidy up areas of pattern. For centuries, neat lines have appeared on beautiful handmade maps as the edge definition or trim, commonly as double lines with marking in between.

Borders and frames are also a form of neat lines because they act as boundaries for the focal point or design. Include a frame on today's Zentangle tile. It can be created from neat lines, broken lines that create broken boundaries, dots and dashes that lead the eve, or a frame that borders the tile.

YOUR STYLE IS ALL AROUND YOU

Look at what you love to find your style. Contributing artist Judy Lehman has loved shoes forever and they appear in her Zentangle Inspired Art. In fact, she has a series of them that continues her love of pattern, visual texture, and attention to detail. Tapestry-like designs emerge in her original artwork.

Fantasy and dreamlike feelings are journaled into her designs—free-flowing organic designs with contrasting geometric areas. Note the Poke Root at the upper heel has been closed with a line and not left open. Judy feels that the line of the shoe was more important. as was keeping an open area.

This piece is titled Never can have too many shoes!

ANOTHER LOVE OF JUDY'S is the perfect accessory, a handbag. For the ZIA today, use achromatic or color. You can either use the string of a handbag provided by Judy, or draw one of your own on an ATC. If you are not into handbags, make yours a hat. Next fill the string with patterns using a pen and shade. You may choose to keep the project on a tile or enlarge it and work on drawing paper.

Copy the pattern onto your ATC or create your own.

Notice the handbag strap is similar to the frame in today's earlier lesson. When too much is a good thing, Judy adds more! But she does so selectively and with compositional balance. She diminished patterns when areas needed to recede throughout. Check out the Knights Bridge in the upper right and the Zander as it curves around the front of the bag like a vintage trim. There is more patterning in the right-hand twist at the top of the handle.

HINTS FROM JUDY: Vary the line drawing by repositioning the bag straighter on your tile, shorten the handle, draw fewer twists in the handle, set smaller flowers to the sides instead of the center, and consider whether or not to string the body of the bag at the beginning. There are so many possibilities! Enjoy the line drawing.

INTRODUCING ZENDALAS

MATERIALS

- 01 pigment ink drawing pen
- pencil
- drawing paper cut to desired size
- template from below
- Koi watercolor markers
- compass
- protractor

ZENDALAS USE THE ZENTANGLE meditative art form. but instead of creating this art on a 3½-inch (8.9 cm) square tile, we use a 4½-inch (11.4 cm) circular tile. This is a great exercise for keeping things fresh and expanding your skills. As a math geek, guest artist Geneviève Crabe has always been attracted by the mathematical structure of mandala, on which the Zendala is based.

When Geneviève creates the framework or template for a Zendala, she usually works on an $8\frac{1}{2}$ x $8\frac{1}{2}$ -inch (21.6 x 21.6 cm) surface, i.e., the largest square cut from an $8\frac{1}{2}$ x 11-inch (21.6 x 28 cm) sheet. To create the circular grid that will be the framework for the design, start by drawing two diagonal lines from corner to corner to create the center. Then use a protractor to draw more lines at specific angles. For example, if you want eight sections around the circle, draw lines every forty-five degrees; for twelve sections, draw lines every thirty degrees.

Use the template for today's meditative exercise and for the ZIA project. The template can be traced or it can be scanned to your computer, resized, and printed out. You can use any of the tangles you have learned. Also, don't be afraid to leave some sections blank. The achromatic version was done on white card stock. Before shading it. Geneviève scanned it and printed a copy on another sheet of card stock for coloring.

Organic in nature, this Zendala template is the string in today's meditative tile.

Then, using a compass, draw a series of circles about a ½ inch (1.3 cm) apart from the center to the edge. Do this in pencil, which will be erased later. Once the circular grid is formed, draw the Zendala lines with a pen, using the pencil lines as a guide to make your design symmetrical. In this particular Zendala, Geneviève drew lines to resemble flower petals.

COLORING YOUR ZENDALA

For the ZIA, Geneviève used the same template and Koi Coloring Brush Pens, which are water-based pens with a great brushlike nib.

"I don't always color all the Zendala's sections," she says. "It can be nice to leave some sections in black and white. In some of my Zendalas. I leave most sections black and white and add just a small splash of a bright color with a marker or add a bit of color with a gel pen or a fine glitter pen."

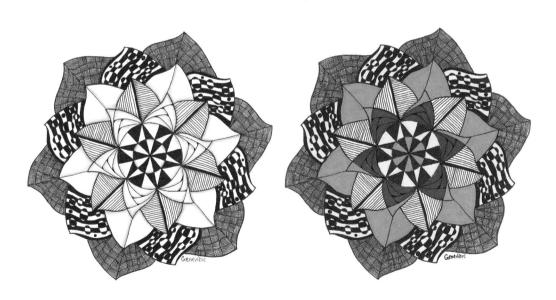

Shading with graphite is often Geneviève's favorite part of tangling, "It seems to inject life into the drawing," she says.

Whatever you use to color in your Zendala, check that it does not bleed on the paper you are using. It is important to have control of the color you apply.

GEOMETRIC ZENDALAS

MATERIALS

- 01 pigment ink drawing pen
- m pencil
- white drawing paper cut to desired size
- colored drawing paper cut to desired size
- template from below
- colored pencils

YESTERDAY'S ZENDALA HAD A mostly organic, flower-like shape, but today's is geometric. All the lines are straight, so all the sections are either triangles or four-sided shapes. Guest artist Geneviève Crabe used the same steps to create the template, but the focus on this template is geometric and a play on angles. Geometry is a favorite subject of hers, and she enjoys playing in this field of shapes.

Geneviève says, "Whenever I see a triangle shape, I think of Rick's Paradox, which is one of my favorite tangles. In this piece, I used Paradox all around the edge of the design, and I added lines in the star shape in the middle. And to add just a little organic touch, I used a variation of Flux."

Copy this template as you did for the first Zendala template, creating a copy for your achromatic tangled Zendala and your ZIA Zendala. Create an achromatic meditative tile using the templates of the day.

COLORING YOUR ZENDALA

For the colored version, the ink drawing was scanned and then printed on a sheet of orange Mi-Teintes paper. The color was selected to match the warm, earth-toned color palette Geneviève chose. Colored pencils were used, in the shades of cream, rusty orange, and dark brown. In addition, black and white were layered sparingly, to darken the shadows and lighten the highlights, giving more contrast to the image. The colored pencil must be applied with a light touch; otherwise, it can cover the ink lines.

A fun exercise for expanding your skills, today's ZIA calls on you to make several copies of the Zendala after inking your tangles. Then try different shading methods or different color schemes. For another exercise, you can use different tangles around the circle, rather than repeating the same ones. Yet another exercise would be to use just one tangle for the whole design. Paradox is a good choice for that; you can create different effects by changing the direction the spiral goes. You could invent your own board game! Think of how you could use this Zendala. There are no rules, so have fun!

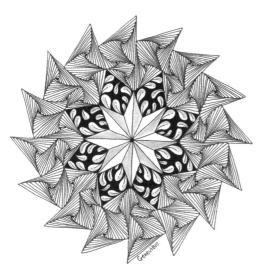

There is less shading here because Paradox creates its own curved shading.

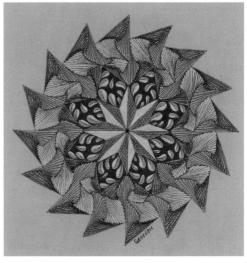

Sometimes you get unexpected results when you finish coloring a piece. In this one, notice how the lightest part of the colored Paradox sections forms an interesting ring around the design.

COMBINING ORGANIC AND GEOMETRIC PATTERNS ON A ZENDALA

MATERIALS

- 01 pigment ink drawing pen
- m pencil
- drawing paper cut to desired size
- template from below
- Inktense colored pencils

IN TODAY'S ZENDALA, Guest artist Geneviève Crabe combined organic and geometric shapes, which engage both the left and right sides of the brain. When you mix different kinds of shapes, you can create an endless variety of Zendalas.

> Geneviève's tangle, Fleurette, is shown in the center of the Zendala below. Fleurette allows you to create symmetrical flower petals with minimal work. It's a very useful tangle for Zendala centers, but you can also use it in many different shapes.

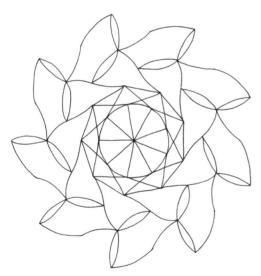

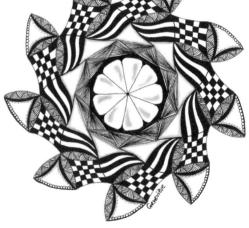

Copy this template as you have for the past two days. If you look at the shapes around the outside, you see that not all the shapes have to be symmetrical. By having the outer shapes all pointing in the same direction, you get a great pinwheel effect.

USE WHATEVER PATTERNS OR TANGLEATIONS you would like to create a meditative Zendala in the achromatic scale.

Starting with Knights Bridge and extending the first column out into the next shape achieved the black-and-white-striped ribbon effect. The center flower is Fleurette, which, as you can see, works great.

The small circles and dots in the outside shapes are flair you can add in any area that needs extra detail.

For the color version. Geneviève scanned the inked Zendala and printed it on 140-lb watercolor paper. For the color, she used Inktense pencils, which are great water-soluble pencils that become permanent when dry.

You can do a variety of things with your Zendalas once you are done. You can scan one and reduce it in size, print it, cut it out, and glue it on the front of a blank greeting card. You can also take several Zendalas, scan them, reduce them to a small size, and print them on round sticker sheets from a stationery store.

Zendalas look great on t-shirts. You can upload one of your designs to an online service. which can put your designs on T-shirts, mugs, tote bags, and more.

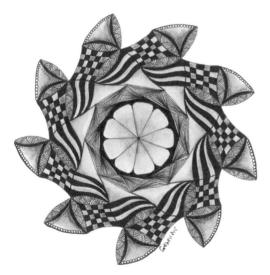

Sometimes, you can extend the template itself. If you look at the narrow petals around the outside, they are in pairs in the template, but in the tangles version, Geneviève added a third petal to the design.

CREATING THE REST OF YOUR ZENTANGLE JOURNEY

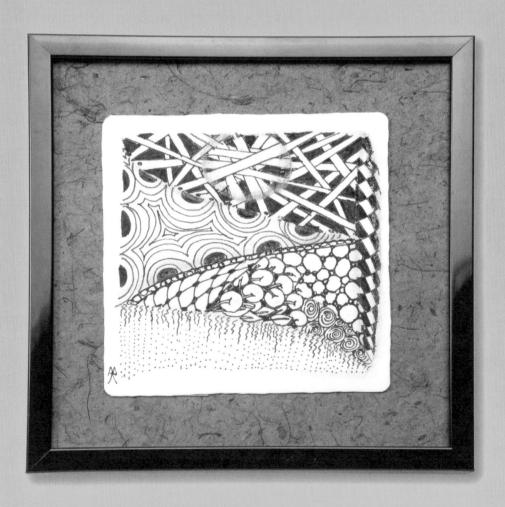

BY NOW SOME OF YOU have found a place for this meditative art form in your daily life. Some of you may see Zentangle as a warm-up tool to put you in the zone before starting to work on a piece of art. Others may find creating a Zentangle tile as a way to kick off their day to a good start. Those with hectic or high-pressured jobs may find the afternoon coffee break is when their brain needs to do a Zentangle tile to refresh.

And yet others may see this as an art form for self-expression or the sheer enjoyment of the process. Many will find it pops up often in their artwork. I encourage you to find the time to continue on your journey. Get involved with artist trading card (ATC) swaps, artist calls for charity, or artist challenges posted on blogs or other websites.

The tiles that you have created in the past five chapters are treasured pieces of art; treat them as such. Choose several of your favorites to frame. Art should be displayed. They will inspire you to continue to create each time you see them. You may choose to frame a small mosaic or frame each separately and hang them in a grouping.

The skills you have acquired do not need to be saved for a tile or sketchbook. There is a pen out there for every surface, so start adorning your world. Your tangles can work for the front of any card. They can make your holiday ornaments unique, change the look of costume jewelry or be made into jewelry, become a new textile pattern, or adorn your dishware. The options are endless.

Card artists: Linda O'Brien, Opie O'Brien, Cris Letourneau, Judy Lehman (three ATCs), Patti Euler (three ATCs), Sandy Bartholomew, Suzanne McNeill, and Ellen Gozeling

Left: My first tangled tile on official Zentangle tiles

CREATING ENSEMBLES

MATERIALS

- 01 pigment ink drawing pen
- 2B pencil
- sketchbook
- white tile
- pre-strung Zentangle tile set or nine white tiles

Practice the new patterns in your sketchbook. When you feel comfortable with the patterns, use them on your daily Zentangle tile. Use a few of the Tangleations and/ or patterns you have created.

CHAPTER 5 COVERED HOW TO look for tangles and develop them. Some of the best patterns I find are during the most inconvenient times. When I do not have time to draw the pattern, I pull out my phone and capture the inspiration in a picture to use later in the day when I do have time. A small digital camera would work as well.

DAILY TANGLES

Try these patterns. Zander, an official Zentangle, works well to lead the eye from one area to the next and transition between different tonal patterns or into another pattern. The second pattern, Stickers, is a Tangleation and is very airy; it does not take too much imagination to figure out that it came from Poke Root, but it is inspired by the pricker balls that are everywhere in southern Texas.

STICKERS

ZANDER

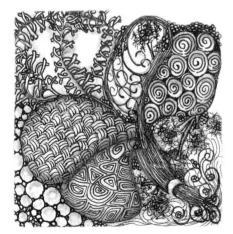

This tile is an example of how overworked a tile can get when we do not stop when we should have.

ENSEMBLES

Ensembles are traditional to Zentangle and are created by laying several tiles together with the sides touching. The string is then drawn across all of them. A traditional Zentangle ensemble is created using nine tiles placed in a mosaic pattern of three rows of three tiles. Then the string is drawn over the nine tiles. When tangles are placed in the ensemble, the artist must be aware of which areas on the tile overlap onto another tile and treat the areas appropriately.

This ZIA project involves creating an ensemble. You can either use a pre-strung Zentangle tile

set or create your own. To create your own, choose from three to nine tiles and lay them, sides touching, in the shape you want the finished piece to be. Using a pencil, draw one string across all the tiles. Number them on the back so you know their order and begin to apply the tangles with a O1 pigment ink drawing pen. Carry the patterns over to the next tile in the areas that run across two tiles. When all the tiles have their string tangled, shade each tile. Carry the shading across the tile borders just as you did the patterns. This is a ZIA exercise, so you can choose to use color or not.

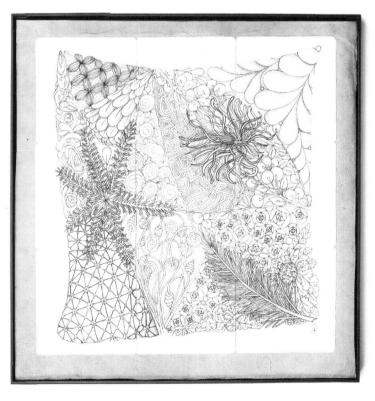

This composition was created on a prestrung geometric ensemble set.

TECHNIOUES FOR MONO PRINTING

MATERIALS

- 01 pigment ink drawing pen
- 05 pigment ink drawing pen
- 2B pencil
- sketchbook
- white tile
- four white tiles or four tiles from watercolor paper
- ATCs (optional)
- Gelato opaque paint sticks, Caran d'Ache crayons, or water-soluble oil pastels
- Barron or large metal spoon
- two 3½" x 3½" (8.9 x 8.9 cm) pieces of acrylic Plexiglas
- sandpaper
- gum arabic
- 3/4" (1.9 cm) flat paintbrush
- paintbrush
- water
- hair dryer (optional)

BOLD PATTERNS DRAW OUR attention, create interest, and add weight to our artwork. One way of doing this is by going over the lines of the pattern a second time. Drawing one pattern with a larger pen nib than the others will also create a sense that the pattern is dominant. Another method is to draw the pattern larger and exaggerated, as when creating a dewdrop, or to round off or silhouette the pattern.

WARMTH

DAILY TANGLES

Try this pattern. Warmth is a pattern that has two-thirds of the lines created with normal lines while the other lines are created with a pen with a larger nib. The larger lines are placed randomly in the piece.

MONOPRINTING

Start by sanding the surface of the acrylic tile in two directions. Wash and dry the acrylic tile. Apply a coat of gum arabic to the acrylic tile and let it dry. Gum arabic is the release agent for the drawing. Once the acrylic tiles are dry, place the paper tiles or ATCs you are going to print on in water to soak. Use the water-soluble crayons of your choice to draw your tangles on the acrylic tile. Because of the size of the crayons' tips, bold patterns work well for this project. You can create a string from a gray crayon. The first layer down will be the top layer when printed, so it is a good idea to place the basic outline of the patterns you are using first. When you are done, take the paper tile or ATCs out of the water and remove any puddles from the surface with a towel. Do not dry them too much. Place the paper right side down on the drawing you created on the tile. Use a Barron or a large metal spoon to rub circles over the entire back surface of the paper tile. Do this a few times. As you are rubbing, you are transferring the drawing to the paper. When finished, remove the paper from the tile, lay it flat, and let it dry. You can print a ghost print of the same drawing by repeating the process on another paper tile. Wash the acrylic tile when done printing. Leave the prints as is or add more.

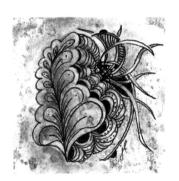

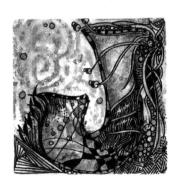

I used a permanent ink drawing pen to add tangles after monoprinting the background.

TANGLED FABRIC

MATERIALS

- 01 pigment ink drawing pen
- 2B pencil
- sketchbook
- white tile
- black cotton duck cloth
- bleach pen
- Tulip fabric markers
- permanent ink pens
- Inktense pencils

IN THE BEGINNING of contributing artist Judy Lehman's Zentangle journey, she drew densely patterned tiles, using almost every pattern she was learning at the time. She favored organic lines and geometric patterns. Now she uses restraint in the number of patterns she uses, focusing on composition and creating a focal point.

Looking at the second tile, notice how patterns seem to be magnified, different from the first tile. Judy is big on negative space, allowing patterns to migrate in and out. She enjoys relaxing with pen and tile each day.

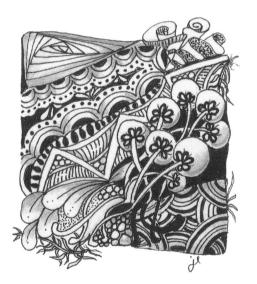

This is a perfect example of how artists use reflection to explore new directions in their work.

CREATING YOUR OWN FABRIC PRINTS

Prewash fabric before bleaching and dry before applying the bleach. Armed with black cotton duck cloth and a bleaching pen, Judy lined off predetermined squares with the pen. It is easy to see the progression from full circles that radiate out from a center to the circled areas that stop and start, appearing to remain tucked behind each other. This is a variation of Sez. The bleach is left on the fabric about two hours for this pillow.

The fabric is rinsed and dried after the desired color is achieved with the bleach. Armed with Tulip paint pens and permanent ink pens, she scattered patterns around, balancing lines, dots, and squiggles. Use Inktense pencils to add color where needed and touch some areas with a wet brush to intensify the color. A challenge is choosing the correct color pencil on the tinted bleach to achieve the desired final hue. To coordinate the focal design with the accent fabric. Judy used a gold paint pen to echo the tiny cheetah print, lines, and extra-thin outline around the square shape. The lightest areas of the lines are the untouched, originally bleached lines.

BLEACHED ENSEMBLE

The bleach set on the fabric overnight to begin this tribal-like image. Test a sample of the fabric as all fabrics have different dve bases and the bleached lines will vary from fabric bolt to bolt as does the length of time the bleach needs to be left on the fabric.

Judy was inspired by the ensemble set of tiles for this high-contrast creation. Spacing is important so all the lines don't run together. Cognizant of scale and pattern detail, Judy drew simple images, leaving negative space for contrast. She used the Tulip paint marker and gold paint pen to enhance the bleached areas.

Judy's attention to detail is seen in the repetition of the cheetah print from the backing fabric into select areas on the duck cloth.

DRAWING TEXTURE AND DRAWING ON MICA

MATERIALS

- 01 pigment ink drawing pen
- W 03 pigment ink drawing pen
- 2B pencil
- sketchbook
- white tile
- m mica
- ArtGraph water-soluable graphite
- small round paintbrush
- water

TEXTURE IS ANOTHER ILLUSION that artists create to bring interest to an art piece. Some of the tangles, such as Shattuck or Warmth, are textural by nature. Patterns that are not textural can be altered to appear that way. Changing a part of the pattern to be larger than other areas, such as in Warmth, is one way. Breaking a solid line of a pattern into a broken line and using perfs and stippling are other techniques that can create texture.

Use some of these techniques on the patterns you draw on your daily Zentangle tile to give some of your patterns texture. Use a white tile and an achromatic scale on the tile with any patterns or Tangleations of your choice. Try to include at least one of the new patterns you have created.

Taking our tangles out of the box takes our work out of the box.

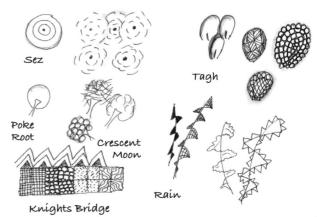

This is a great warm-up exercise and a chance to change a pattern you do not enjoy using into one you will use more.

MICA

Mica is a mineral that comes in many colors. Industrial grade is usually orange because of the shellac that holds it together. It is sanded and tends to come in sheets that are about 1/8-inch (3.2 mm) thick and opaque in nature. Natural mica comes in many colors, including green, white, orange, and clear. Today's projects are made from a mix of the above, which can be found on the Internet. Most of the pieces used came from grab bags of deckled or colored mica. Mica can be separated into thinner layers and in most cases is transparent or semitransparent. The same technique was used to create the first two pieces. I used a 03 permanent ink drawing pen. I look at the natural patterns on the mica and use that as my string. On any ascending line, or line of the design that was in the forefront, I drew it on the front. Any descending line or line that was from the background, I drew on the back. Try creating your own tangle on mica.

The mix of orange, semiopaque, and clear areas on this piece of mica are perfect for this technique. ArtGraf water-soluble graphite was used for shading.

This ensemble started out as four pieces of all the same height. I broke the edges away to create the four deckle edges. I drew the tangles across the four pieces using the above technique.

LETTERS AS STRINGS

MATERIALS

- 01 pigment ink drawing pen
- two 2B pencils
- white tile
- sketchbook
- 8½" x 11" (21.6 x 28 cm) piece of paper
- rubber band
- colored pencils

USING CALLIGRAPHY WITH Zentangles is one way that guest artist Angie Vangalis likes to string a tangle. To start her string, she makes a ribbonlike letter using a double-pencil technique. A double-pencil technique uses two pencils held together with a rubber band, forming a broad-edged calligraphic tool. Try this technique on a large piece of paper, keeping the pencil points at a forty-five-degree angle as you glide across the surface of the paper. The ribbon-like marks make wonderful channels for borders and letters to tangle in. You can also band together two pigment ink or permanent ink pens for permanent outlines. Either way, Angie likes to separate the letter from the background by adding an aura around the entire letterform with a pencil. Then, when the entire background is tangled, stop at the penciled aura to hold a white area around the letter. Last, shade the letterform with water-soluble graphite. Another way to add a white aura is to draw a nervous line around the area and then tangle up to the nervous line.

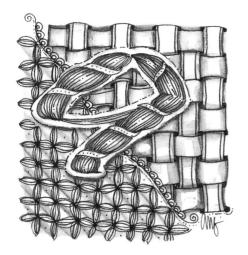

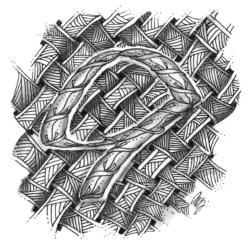

Keeping the aura around the letter even allows it to blend into the piece. If the aura is uneven, it will attract attention.

The broken-line border around each letter harmonizes their unique shape.

I love the playfulness of the double-line pencil letters. I find them more stylized, neater, and consistent than most bauble letter techniques.

Here Angie added color to the text with colored pencils. Achromatic or colored, they remain beautiful.

ZIA

Each letter in the word peace was written with the double-pencil technique, creating a string. Like a Zentangle, the tangles within each of the letters are drawn one stroke at a time. Finery, Shattuck, Zander, Fife, and Bales embellish these letterforms, and then they are finished off with shading and a nervous line.

FOLK PATTERNS AND RESIN

MATERIALS

- 01 pigment ink drawing pen
- 2B pencil
- Identi-Pen
- sketchbook
- white tile
- 3½" x 3½" (8.9 x 8.9 cm) piece of Ampersand Claybord
- Mod Podge Hard Coat
- $= \frac{1}{2}$ " (1.3 cm) paintbrush
- Gel du Soleil and a UV light or ICE Resin
- grey Glaze gel pen

MANY FOLK PATTERNS break down into very simple oneto three-stroke patterns. They are the influence for today's patterns. Research the folk patterns from your or any other heritage for inspiration in creating new tangles. Many of these patterns have meanings you might also like to take notes on.

Practice these or a few from your own heritage in your sketchbook. When you are comfortable with them, create your daily Zentangle tile. You can combine it with any patterns or Tangleations you choose to use, preferably some that you have created.

The closed coil pattern, which is used for a wild rose, has been used for centuries to symbolize happiness. Used singly, it stands for a wish for a happy day, in threes a happy event, and in a cluster, a lifetime of happiness.

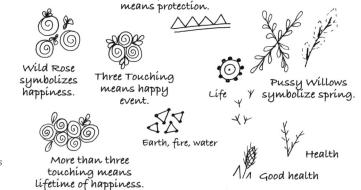

Wolf's teeth

RESIN

Today's ZIA offers a whole new way to add dimension to tangled tiles. By dividing the drawing with two layers of resin, we will create dimension and an effective 3-D technique.

Resins basically come in two types. Gel du Soleil requires no mixing. It can cure in twenty minutes when placed in bright sunlight or under a UV light. The light must be able to penetrate anything embedded in the resin for the resin to cure. Two-part resin such as ICE Resin also works for this, but you must let it cure twenty-four hours between layers. Both will work for this project.

In your sketchbook, plan the string and place the tangles in the areas you want them. Divide the design into three parts: a background, middle ground, and foreground. Proceed to the Claybord. Draw the string in pencil and the tangles that are in the background with an Identi-Pen. Now only shade the background area. Make sure the pen is dry and then use a paintbrush to apply Mod Podge to seal the ink and graphite. Make sure the sealer is dry before proceeding. Apply a layer of resin, being cautious not to get it thicker than 1 to 2 millimeters. Pop any air bubbles with a pin. Bring the resin out to the edges with a skewer. The resin must be cured before moving on. The thicker the resin, the longer it takes to cure. Use an Identi-Pen to draw the middle-ground patterns. Shade the middle grounds with the gray Glaze gel pen. When the ink is dry, repeat the resin step and cure the resin. Draw the foreground and shade with a gel pen. Apply a third layer of resin and cure.

It's worth the time, so wait between applying layers. ICE resin allows you to pour a thicker layer, thus giving the most depth.

The depth achieved with this technique is very exciting.

SIMPLE LINE DRAWING

MATERIALS

- 01 pigment ink drawing pen
- 2B pencil
- sketchbook
- two or three white tiles

Today's Zentangle tile is a celebration of your absolute favorites, starting from the string you draw to the patterns you pick. Include any Tanglenhancers and Tangleations. Remember the eleven steps to creating a tile. Take the time to examine the tile and turn it after you finish the first pattern. Let the tile develop one pattern at a time and after completing a pattern, examine the tile from every angle before proceeding to the next pattern.

BRONX CHERRY

If I had given this pattern in chapter 1, it would have been highly overused.

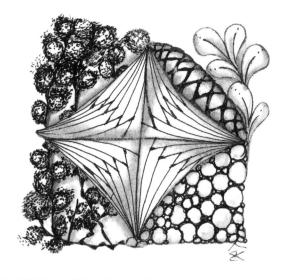

The tile is divided into half Tangleations and half patterns.

DAILY TANGLE

Try this pattern. Our last pattern is the only official Zentangle I know that has a purpose. The Bronx Cherry covers mistakes. Better than erasing, you can always draw over that problem area.

LINE DRAWING

Many of my tangled journaling pieces start from a simple line drawing. Everything is simplified; there is not a lot of detail in the faces or buildings. Sometimes every bit of the paper or tile is filled in with pattern, other times just a few areas. Many times I lay down my string drawing with a pencil and then fill in and add details with a pen. Two-thirds of my journaling remain in the achromatic scale, with a third adding color. I like to let the graphics speak for themselves and add few words, if any. If you are uncomfortable with trying to draw people, start with trees and plants, simple geometric buildings, or a combination of the two. You can also take a magazine picture or other picture to the light box and trace around the objects. Use graphite transfer paper to transfer the drawing to your sketchbook, paper, or tile.

The tree was drawn with Gelato pens and the owl with gesso. Ink tangles were applied and then gesso was used for highlights.

A sketch done in Seattle that uses tangles to fill in some delectable details.

This sketchbook was covered with watercolor ground. tangled in ink, and shaded with Inktense pencils.

APPENDIX

MAKING AN ATC AND ZENTANGLE TILE CARRIER

For an ATC, use a piece of paper that is 8 x 12 inches (20.3 x 30.5 cm). For a Zentangle tile holder, start with a piece of paper that is 9 x 15 inches (23 x 38 cm). Fold on the red lines.

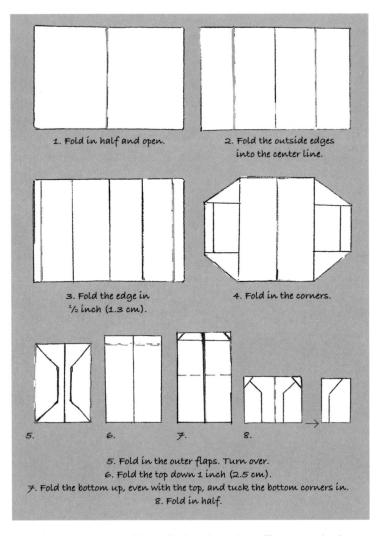

Made from Lokta paper, this carrier has six pockets. The outer edge is a pocket, with two on the outside and two inside.

RESOURCES

ART AND SOUL RETREATS

www.artandsoulretreat.com

DANIEL SMITH

Art supplies for watercolors and watercolor ground www.danielsmith.com

DESIGN MICA COMPANY

Daniel Essig's company carries a wide range of both natural and industrial mica in all colors. www.etsy.com/shop/danielessig www.danielessig.com

ICE RESIN

Susan Lenart Kazmer's Ice resin and jewelry components for putting your tangles in www.iceresin.com

QUEEN'S INK

Zentangle supplies including clay boards, Gelatoes, Soleil, and curing lamp www.queensink.com

TEXAS ART SUPPLY

For pastels, colored pencils, Art Graph watercolor graphite, Copic Markers, water-soluble wax crayons, oil pastels, and general art supplies www.texasart.com

ZENTANGLE HOME PAGE

Your local CZT is your closest source for tiles, Zendallas, pens, and classes in your area. To find your closest CZT go to www.zentangle.com.

PAPER WINGS PRODUCTIONS

On-line store for a wide range of mixed-media supplies

www.paperwingsproductions.com

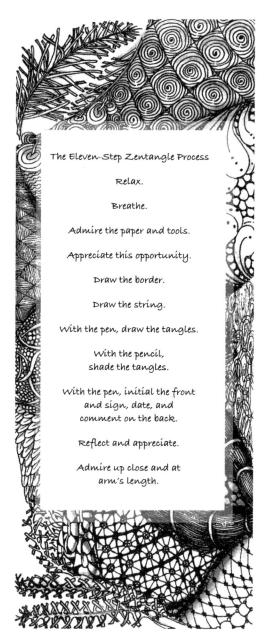

ABOUT THE AUTHOR

BECKAH KRAHULA is an artist, published author, product designer and developer, and maker. She has taught nationally and internationally since 1996. She has been practicing Zentangle for four years and was certified as a Zentangle teacher in 2011. Her innovative art, products, ideas, tips, class schedules, and online classes can be found at www.beckahkrahula.com. Follow her passion for tangling, her Zentangle journey, and inspiration for daily tangling and creating art on her blog, www.thedailytangler.com.

ARTIST CONTRIBUTORS

ANGIE VANGALIS is a dedicated creative professional, lettering artist, author, product developer, and teacher. Angie earned a BA degree in art and has been certified as an official Zentangle Teacher (CZT) and in Copic Markers. Visit her at www.vangalis.co.uk or www.angievangalis.com.

JUDY LEHMAN is an experienced designer and textile and fiber artist, who has toured and taught nationally and internationally, as well as an elementary art teacher. Judy, a certified Zentangle teacher, saw the potential for Zentangle to help students in the classroom and has incorporated it into her curriculums. Contact her at lehmanjudy@sbcglobal.net.

Following a thirty-year career in high-tech, GENEVIÈVE CRABE is now devoting her time to artistic pursuits. She is a Certified Zentangle Teacher and creates and publishes tools for Zentangle and Zendala artists. Visit her at www.tangleharmony.com.

Contributors featured throughout the book are the following:

BETTE ABDU www.betteabdu.com

SANDY BARTHOLOMEW www.sandysteenbartholomew.com

PATTI EULER
Queens@Queensink.com

ELLEN GOZELING

CRIS LETOURNEAU www.TangledUpInArt.wordpress.com

SUZANNE MCNEILL www.sparksstudio.snappages.com

LINDA O'BRIEN AND OPIE O'BRIEN www.burntofferings.com